WITHDRAWN

O9-CFT-934

GEORGIA O'KEEFFE

AN ETERNAL SPIRIT

Susan Wright

NEW LINE BOOKS

Copyright © MMVI by New Line Books Limited
All rights reserved.
No part of this publication may be reproduced, stored in a retrieval system or transmitted in any form by any means electronic, mechanical, photocopying or otherwise, without first obtaining written permission of the copyright holder.

Fax: (888) 719-7723
e-mail: info@newlinebooks.com

Printed and bound in Singapore

ISBN 1-59764-093-X

Visit us on the web!
www.newlinebooks.com

Author: Susan Wright

Publisher: Robert M. Tod
Editorial Director: Elizabeth Loonan
Book Designer: Mark Weinberg
Production Coordinator: Heather Weigel
Senior Editor: Edward Douglas
Project Editor: Cynthia Sternau
Assistant Editor: Don Kennison
Picture Reseacher: Laura Wyss
Desktop Associate: Paul Kachur
Typesetting: Command-O, NYC

Paintings by Georgia O'Keeffe
in this book are published
with the permission of the
Georgia O'Keeffe Foundation

Picture Credits

The Albuquerque Museum, New Mexico 107
The Art Institute of Chicago 11, 17, 26, 39, 54, 55, 81, 83, 95, 122
Arizona State University, Art Museum, Tempe 103
The Baltimore Museum of Art, Maryland 76, 77
The Beinecke Rare Book and Manuscript Library, Yale University, New Haven 20
The Bettmann Archive, New York 4, 10 (top), 49, 50, 51
The Brooklyn Museum, New York 124–125
The Carl Van Vechten Gallery of Fine Arts, Fisk University, Tennessee 44
The Cleveland Museum of Art, Ohio 75, 110
Corbis-Bettmann, New York 48
The Corcoran Gallery of Art, Washington, D.C. 99
Dallas Museum of Art 36
Frances Lehman Loeb Art Center, Poughkeepsie, New York 52
The Gerald Peters Gallery, Santa Fe 37
Hirshhorn Museum and Sculpture Garden, Smithsonian Institution, Washington, D.C. 86, 119
The Metropolitan Museum of Art, New York 6, 22, 62, 80, 84, 109, 115
Milwaukee Art Museum, Wisconsin 113, 120–121
The Minneapolis Institute of Arts, Minnesota 43
Museum of Fine Arts, Boston 18–19, 64
Museum of Fine Arts, Museum of New Mexico, Santa Fe 8–9
The Museum of Modern Art, New York 25, 29, 45, 53
Munson-Williams-Proctor Institute, Museum of Finr Art, Utica, New York 91
Myron Wood Photographic Collection, Pikes Peak Library District, Colorado Springs 10 (bottom), 16, 90, 96, 98, 106, 114, 116, 117, 118, 124, 126
The National Gallery of Art, Washington, D.C. 59, 100
The Nelson-Atkins Museum of Art, Kansas City, Missouri 78
New Jersey State Museum, Trenton 15
The New Orleans Museum of Art 12–13
The New York Public Library 28
The Newark Museum, New Jersey 56–57
The Norton Gallery of Art, West Palm Beach, Florida 87
The Philadephia Museum of Art 33, 47, 63, 108
The Phillips Collection, Washington, D.C. 30, 35, 92, 97
The Saint Louis Art Museum 27
The San Diego Museum of Art 34, 66–67, 88–89
San Francisco Museum of Art 74, 93
Thyssen-Bornemisza Collection, Lugano 38
The University of Arizona Museum of Art, Tuscon 60
The University of New Mexico Art Museum, Albuquerque 123
University Art Museum, University of Minnesota, Minneapolis 72–73
UPI/Bettmann, New York 101
Wadworth Atheneum, Hartford 104–105
The Walker Art Center, Minneapolis 31
The Whitney Museum of American Art, New York 21, 71, 127
Wichita Art Museum, Kansas 41
Yale University Art Gallery, New Haven 69

CONTENTS

INTRODUCTION

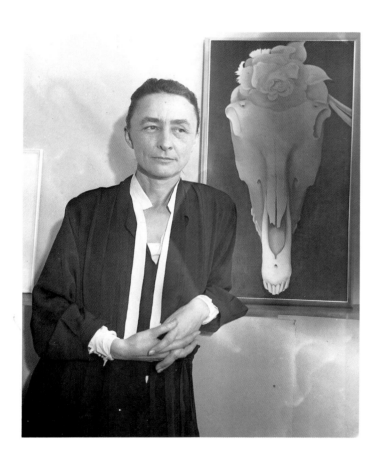

O'Keeffe with Skull Painting

UNKNOWN PHOTOGRAPHER, 1931.

The Bettmann Archive, New York.

In an effort to bring the New Mexico desert to the city, O'Keeffe sent barrels full of bones back to New York. She spoke of them as her treasures, and created many of her bone paintings during the winter months in New York.

Early in 1915, when she was twenty-eight and teaching art in South Carolina, Georgia O'Keeffe decided to take stock of her career. According to her friend Anita Pollitzer, the artist hung all of her paintings around her room and proceeded to go through a monumental self-evaluation of her work. O'Keeffe by then had studied at several schools around the country under notable teachers of the time. She concluded that each one of her paintings was derivative of these influences and so destroyed every piece.

The destruction of O'Keeffe's early work leaves a tantalizing mystery in her oeuvre, particularly since she explored in depth certain subjects and themes, returning to them again and again during her long and prolific career. Her early visits to Lake George, New York, in 1907, and to Amarillo, Texas, in 1912, were the genesis of long-standing obsessions with both the Lake George region and the southwest, yet none of these early works survived.

O'Keeffe's love of nature was surely inspired by her childhood in Wisconsin. She was born on November 15, 1887, in Sun Prairie, and grew up among the hundreds of acres of her family's large dairy farm. As O'Keeffe said near the end of her career, "What's important about painters is what part of the country they grow up in." She called her homeland in the midwest ". . . the normal, healthy part of America," and credits it as the foundation for the development of her art.

O'Keeffe's mother encouraged early art instruction for all of five of her daughters—just as she herself, and O'Keeffe's grandmother before her, had received art training when they were young girls. In the nineteenth century, farm women in the area were expected to decorate their own furniture and walls with colorful, floral patterns.

Yet, early on, O'Keeffe knew that she would devote her life to art, believing at first that she would be a "portraitist." Most of the works that remain from her childhood and teens are portraits of family

and friends. (When she was fourteen and studying art at Sacred Heart Academy near Madison, Wisconsin, one of the nuns criticized O'Keeffe's drawing of two hands for being "too small." O'Keeffe later said that this motivated her never to draw anything too small again.)

ART STUDENT

When her family moved to Virginia in 1903 to escape the harsh Wisconsin winters, O'Keeffe studied art at the Chatham Episcopal Institute. Sixteen-year-old girls in this part of the country dressed like old-fashioned southern belles in corsets and petticoats, with their long hair styled and curled in ringlets. O'Keeffe was different. She usually pulled her hair back in a simple ponytail, and wore suit-coats or plain white dresses.

Two years later, when she was eighteen, O'Keeffe went to stay with her aunts in Chicago so she could attend the School of the Art Institute of Chicago. There, she took top honors in the life drawing classes of John Vanderpoel, who was, according to O'Keeffe, one of the few "real" teachers she had known.

O'Keeffe, though, had mixed feelings about the Institute. When she was comfortable drawing the nude male models, she was instructed to copy Old Master paintings in painstaking detail. According to the Institute's *Circular of Instruction*, the school fostered "the highest efficiency [in] the severe practice of academic drawing and painting." Competition for the front seats in the drawing classes was fierce, but by the end of the first term O'Keeffe had risen to the top quarter of the class.

Then, in 1907, O'Keeffe enrolled in the Art Students League in New York City. There she earned a scholarship under the tutelage of William Merritt Chase for her painting *Rabbit and Copper Pot*. A copy of this painting survived her later self-evaluation only because it was retained for exhibition by the Art Students League.

The scholarship from the Art Students League allowed her to spend the summer at Lake George, where she was able to paint outdoors for the first time. However, financial difficulties soon forced O'Keeffe to leave her art studies, and she returned to Chicago to work as a commercial artist. There she designed the logo for Little Dutch Girl cleaner, which

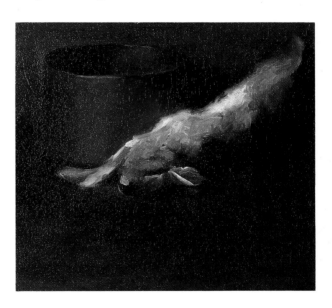

Rabbit and Copper Pot (Still Life with Hare)
1907, oil on canvas; 19 x 23 1/2 in. (48 x 60 cm).
The Art Students League of New York, New York.
This work is one of the rare extant paintings made while O'Keeffe was studying with William Merritt Chase at the Art Students League in New York. In 1923 O'Keeffe wrote of that time, "I loved the color in the brass and copper pots and pans, peppers, onions and other things we painted for him."

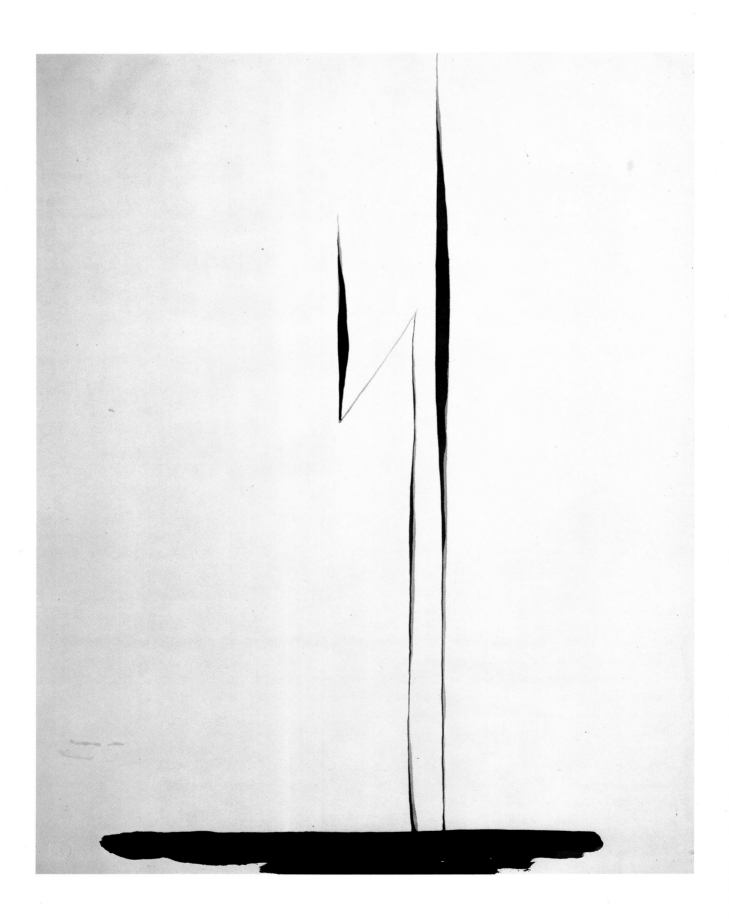

was an enduring commercial success, yet she always regretted the few commercial commissions she accepted. Decades later, in 1939, a commission for the Dole Pineapple Company in Hawaii presented O'Keeffe with a trip to the islands for the first time. The artist only reluctantly completed a painting of a pineapple, preferring instead to paint the flowers and sky of the Pacific.

For two years in Chicago, O'Keeffe illustrated lace panels for several advertising agencies, working twelve-hour days, six days a week. Then, in 1910, a severe bout of the measles temporarily blinded her, and she was forced to give up her career as a graphic artist, returning to her family in Virginia to recover. After that dismal experience, she did not even try to paint anything of her own, saying "I'd been taught to paint like other people, and I thought, what's the use?"

ART TEACHER

O'Keeffe's first artistic crisis lasted until she was twenty-four. In 1912 she enrolled briefly at the University of Virginia, Charlottesville, where her sisters were taking art classes. Anita O'Keeffe particularly had become concerned that her sister was not producing art, and therefore encouraged her to come hear the revolutionary art instructor, Alon Bement.

Alon Bement had studied the Dow Method, created by Arthur Wesley Dow, which encouraged students to produce original work instead of copying the works of others. In an 1899 edition of *Composition*, Dow wrote, "That which anybody can do, is not worth doing. If your drawing is just like your neighbor's it has no value as art." This belief became the foundation of O'Keeffe's art. Though the classes were intended to produce art teachers for children, O'Keeffe leapt at the chance to begin assisting classes for Bement at the University of Virginia.

Blue Lines X

1916, watercolor on paper; 25 x 19 in. (64 x 48 cm).
The Alfred Stieglitz Collection, The Metropolitan Museum of Art, New York.
Stieglitz once referred to this painting as an embodiment of sexual principles, but for O'Keeffe, it was the ultimate in a series of linear abstractions. The lines and colors have been composed so that they impart a distinct message—a practice that O'Keeffe called "the very basis of painting."

That autumn, O'Keeffe moved to Amarillo, Texas, teaching art for the first time, for two years, in a local high school. The first public showing of her work was also in 1912—her painting, *Scarlet Sage*, was included in the annual exhibition of the American Water Color Society at the National Arts Club in New York.

Early during her stay, O'Keeffe stumbled on Palo Duro Canyon, a narrow, eroded chasm in the vast Texan plain. Called the Grand Canyon of Texas, O'Keeffe renamed it the "slit" and she struggled to capture the beauty of the color and the light, and the way she felt at the bottom of its crevice. None of her work from this period has survived, but later, during her first few years in New York, her impressions of Texas would inspire her first great abstractions.

In 1914, at the age of twenty-seven, O'Keeffe returned to New York to study again at the Art Students League. At the same time, she attended Teachers College at Columbia University so she could obtain better teaching posts. O'Keeffe met Anita Pollitzer at the Art Students League at this time, and impressed other students as well with her daring, imaginative designs.

It was during one of O'Keeffe's periodic, financially necessary stretches of teaching the following year (this time at Columbia College, South Carolina) that she underwent the radical self-critique of her work, and decided it was all valueless as art.

ARTIST

The destruction of her paintings led O'Keeffe to produce a flurry of new drawings, done entirely in her singular, expressionist way, and in December of 1915 she sent some of these spare, abstract charcoal drawings to Anita Pollitzer, who was still living in New York. Pollitzer was struck by the "promise and sensitiveness" of the drawings. Though O'Keeffe had instructed her friend not to show the charcoal studies to anyone, Pollitzer took the drawings to Alfred Stieglitz—a noted photographer and one of America's foremost promoters of modern art—who was then at his well-known gallery, "291."

To Stieglitz the drawings came as a a revelation, and as Abraham Walkowitz, one of the early artists of 291 said, Stieglitz saw "a new expression of things felt, a new beauty" in O'Keeffe's work. Pollitzer reports that Stieglitz exclaimed, "Finally, a woman on paper!"

The artist and gallery owner was so impressed with

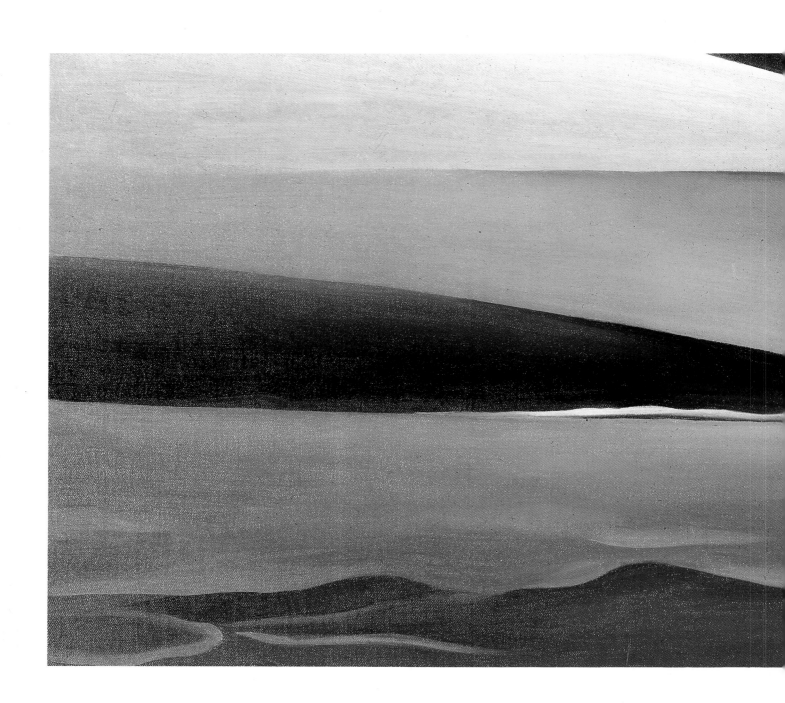

Bear Lake (Desert Abstraction)

1931, oil on canvas; 15 1/2 x 36 1/2 in. (39.4 cm x 92.7 cm). Museum of New Mexico

Foundation Collection, Museum of Fine Arts, Museum of New Mexico, Santa Fe, New Mexico.

Completed soon after O'Keeffe had begun her visits to the Southwest, this early abstract work is built around light on the mountains, truly "distances in layers."

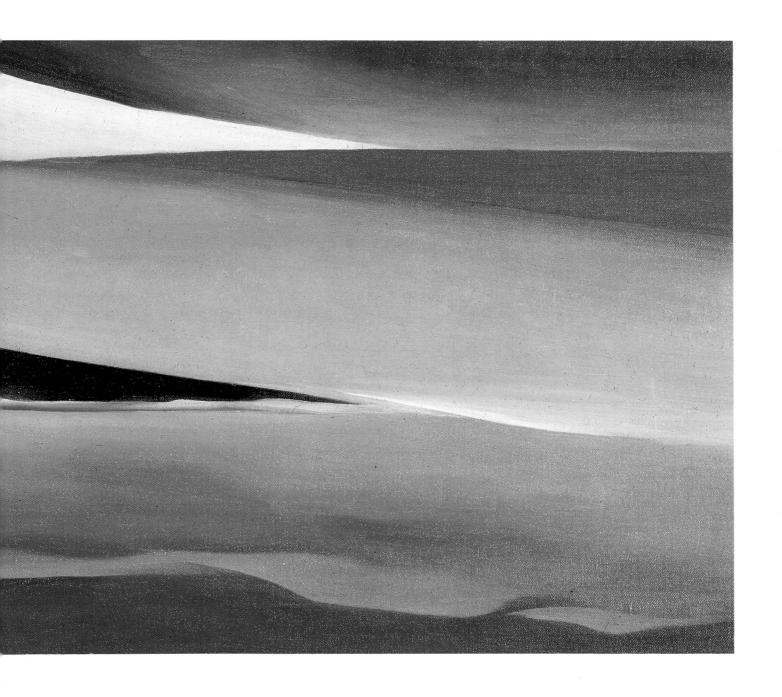

O'Keeffe and Stieglitz at
An American Place in the 1940s

UNKNOWN PHOTOGRAPHER. The Bettmann Archive Inc., New York.
Throughout the 1930s and 1940s Stieglitz refused to travel
to the southwest. He was busy running his gallery, and
would only spend his summers in his beloved Lake George.

O'Keeffe's work that he exhibited her drawings at 291
without having first received her permission. During
a visit to New York, she descended on the gallery in
anger and demanded that her "private" drawings be
returned, but Stieglitz persuaded her to allow the
exhibit to remain standing.

Eventually, Stieglitz also persuaded O'Keeffe to
move to New York, and years later they married. For
the rest of his life he continued to show her work to a
wide variety of critical acclaim in his New York gal-
leries. After 291 closed, Stieglitz promoted her paint-
ings along with contemporary European art at the
Intimate Gallery. O'Keeffe was one of his special
group of five American artists, which also included
John Marin, Marsden Hartley, Arthur Dove, and
Charles Demuth. After 1930 Stieglitz opened yet
another popular gallery, An American Place, where he
continued to hold annual exhibits of O'Keeffe's art.

Rio Grande River—The Gorge

*MYRON WOOD, 1979–1981; photograph. Myron Wood Photographic
Collection, The Pikes Peak Library District, Colorado Springs, Colorado.*
This dramatic gorge is 5 miles (8 kilometers)
southwest of Taos, part of the stark landscape that
O'Keeffe explored on her first trip to New Mexico.

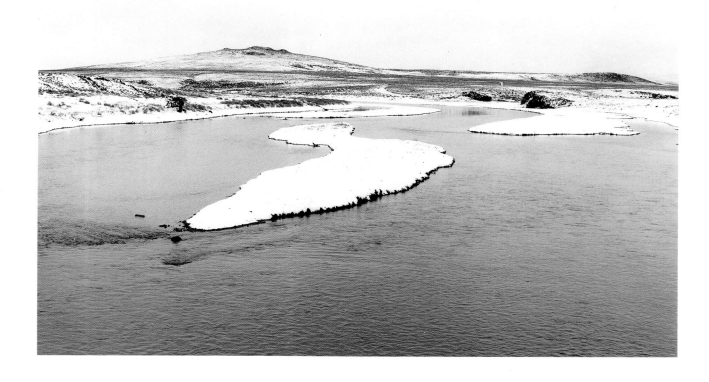

With the support of Stieglitz and the help of early positive reviews and sales, O'Keeffe was able to devote herself entirely to painting. She created abstractions that attempted to capture the sensations of the Texas plain; the innovative construction of New York City skyscrapers at night; the rural landscapes and still lifes of Lake George; and, of course, the gorgeous flowers for which she would become famous. All were produced in the brilliant, light-filled colors and meticulously delineated patterns she found through her resolute study of details. O'Keeffe had an almost oriental sense of simplicity that she credited to her training with Alon Bement who, as she said, taught her "to fill a space in a beautiful way."

Stieglitz, in return, acknowledged that O'Keeffe inspired him artistically with her lack of emphasis on formal theory. He began his photographic "portrait" of her in 1917, and continued it for the rest of his life. He created hundreds of prints of her, zeroing in on her expressive hands, face, and body, and the intimate focus of these nudes gave the photographs an instant, erotic charge.

In 1923 Stieglitz presented one hundred of O'Keeffe's pictures at the Anderson Gallery on Park Avenue, where he had been offered exhibition space. A month later, he exhibited a group of his intimate portraits of her nude body. The critical response to O'Keeffe's work became forever complicated by her prominent status as an artist and a model, encouraging speculation about the possible sexual and symbolic aspects of her own art. Stieglitz encouraged these interpretations, but O'Keeffe found the questions invasive, and continued to insist that her paintings should be able to speak for themselves.

O'Keeffe was a remarkably independent woman

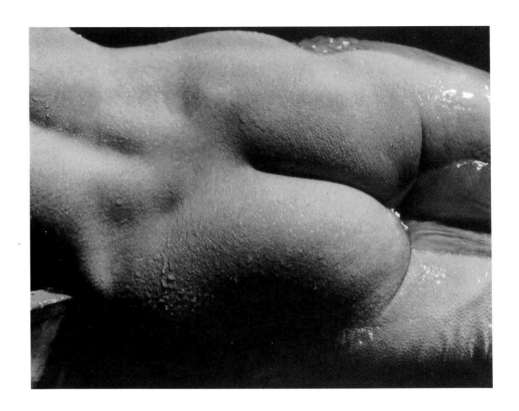

Lake George

ALFRED STIEGLITZ, 1922–23; photograph. The Alfred Stieglitz Collection, The Art Institute of Chicago, Chicago, Illinois. Stieglitz created hundreds of prints of O'Keeffe's expressive hands, face, and body, and his intimate focus on her body gave these photographs an often erotic charge.

throughout her life, despite the fact that her early relationship with Stieglitz was complicated by her dependence on him for financial support. She also depended on him for artistic support, for as much as she may have disliked the critics' discussions and the pressure of exhibiting every year, Stieglitz ensured that O'Keeffe's art was taken seriously.

O'Keeffe never claimed to be a feminist, yet her early efforts toward equality were notable. She joined the National Woman's Party in 1914 at the urging of Anita Pollitzer, who became the national chairperson in 1945. In 1926 O'Keeffe addressed a party convention in Washington, and also lobbied Eleanor Roosevelt during the campaign for an equal rights amendment. She believed that no child should be barred from "any activity that they may choose" on account of their sex.

O'Keeffe once admitted, "I believe it was the work that kept me with [Stieglitz]—though I loved him as a human being." Their separation during the 1926 National Woman's Party convention was the first of what became frequent and long seasons spent away from each other. In 1929 she traveled to New Mexico to spend her first summer in blessed isolation in order to paint. Thus began a cycle that would last for almost two decades, spending winters with Stieglitz in New York and summers in her beloved desert.

According to friends and family, O'Keeffe and Stieglitz were obviously in love for their entire lives. They wrote frequently during their separations, and confided their feelings about things both personal and professional. In 1937 O'Keeffe wrote rapturously to Stieglitz about the colors of the desert and the painting she was working on, adding that he would have loved the sight of the evening sky from the hill as much as she did. Her inclusion of him in her memory of the event seems to make her miss him, and despite her obvious pleasure at being in the desert, she adds, ". . . I wonder should I go to the lake [Lake George] and have two or three weeks with you before you go to town. I will if you say so. Wire me and I will pick right up and start."

After Stieglitz died in 1946, O'Keeffe moved permanently to New Mexico. Her second major retrospective took place in 1970, at the Whitney Museum of Art in New York, after she had worked in comparative isolation for a number of years. She returned to the art world during a period rich in the social commentaries and ironies of Pop Art, with minimalists and conceptual artists doing things that nobody previously ever thought could be considered art.

For the first time, O'Keeffe was without the glare of the spotlight that Stieglitz had usually helped to provide, but her lack of confidence did not keep her from including a substantial body of new southwestern studies among her 121 paintings, spanning the fifty-five years of her career. The response to the Whitney show served to prove O'Keeffe's enduring brilliance as a major artist.

During her lifetime, O'Keeffe won countless honors and awards, including the Medal of Freedom, the highest American civilian honor, from President Gerald Ford, and the Gold Medal for Painting by the National Institute of Arts and Letters. She was elected to the American Academy of Arts and Letters, filling the seat after the death of e. e. cummings in 1962.

O'Keeffe arranged annual exhibitions of her own work as well other artists in various New York galleries owned by Stieglitz. She had numerous one-person exhibitions in prominent galleries, as well as at the Art Institute of Chicago, the Museum of Modern Art, the Whitney Museum of American Art, and many others. She has often been referred to as the

greatest American woman artist. In 1949, when O'Keeffe was elected Member of the National Institute of Arts and Letters, the president of the Institute, poet and novelist William Rose Benét, called her ". . . one of the most widely known painters in America." And she remained so until the day she died, at the age of ninety-eight, on March 6, 1986.

O'Keeffe herself always disdained the use of any superlatives or qualifiers for herself, and preferred to be remembered, "As a painter—just a painter."

My Backyard

1930, oil on canvas; 20 x 36 in. (50.8 x 91.4 cm).
The New Orleans Museum of Art, New Orleans, Louisiana.
Attracted by the beautiful and lonely vistas of the southwest, O'Keeffe called the cliffs and canyons of New Mexico "my backyard." Although Stieglitz did not accompany her there during their years together, he knew that the landscape was necessary for her art.

East River from the Shelton

1927–28, oil on canvas; 27 1/16 x 21 15/16 in. (68.7 x 55.7 cm).
Purchased by Friends of the Museum with a gift from Mary Lea Johnson,
FA1972.229, New Jersey State Museum, Trenton, New Jersey.
The organic forms of O'Keeffe's contemporary flower
studies emerge in the soft folds of the river, which dominate
the misty, smoke-filled landscape beyond Manhattan.

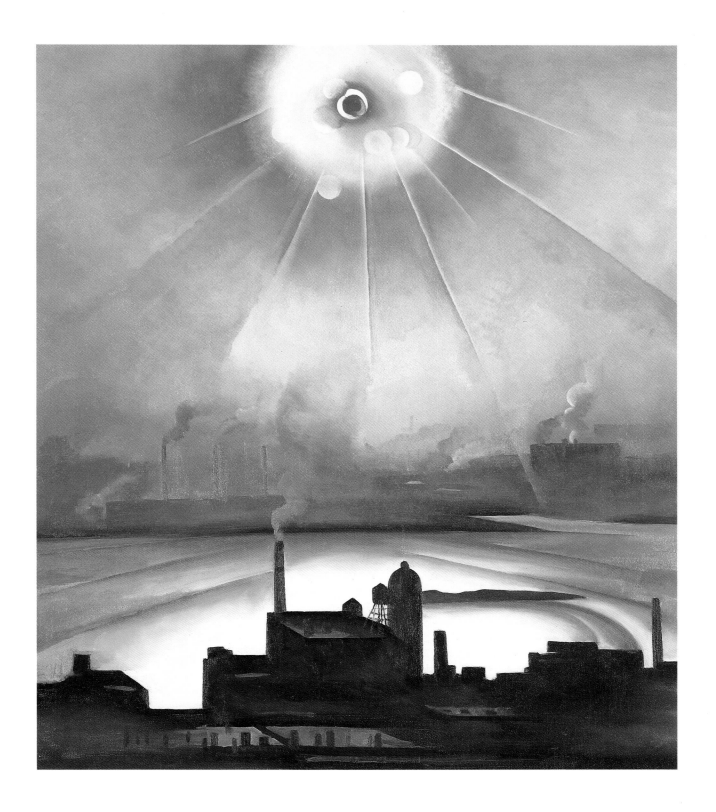

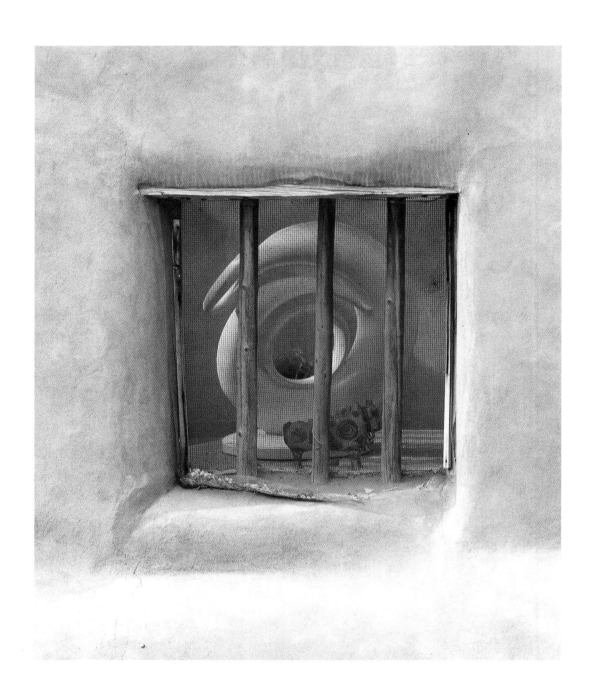

Stoa-Sculpture

MYRON WOOD, 1945; photograph. Myron Wood Photographic Collection,
The Pikes Peak Library District, Colorado Springs, Colorado.
Here is one of O'Keeffe's rare sculptures, in which the
spiral of life is rendered in three-dimensions.
The edges are as smoothly modeled as her paintings.

Black Rock with Blue Sky and White Clouds

1972, oil on canvas; 35 1/2 x 30 in. (91.4 x 76.8 cm). The Alfred Stieglitz Collection,
Bequest of George O'Keeffe, 1987.250.3, The Art Institute of Chicago, Chicago, Illinois.
Despite the fact that she lost her central vision in the early 1970s,
O'Keeffe continued to work. Here, her active focus on sculpture
during this period is also reflected in two dimensions, on canvas.

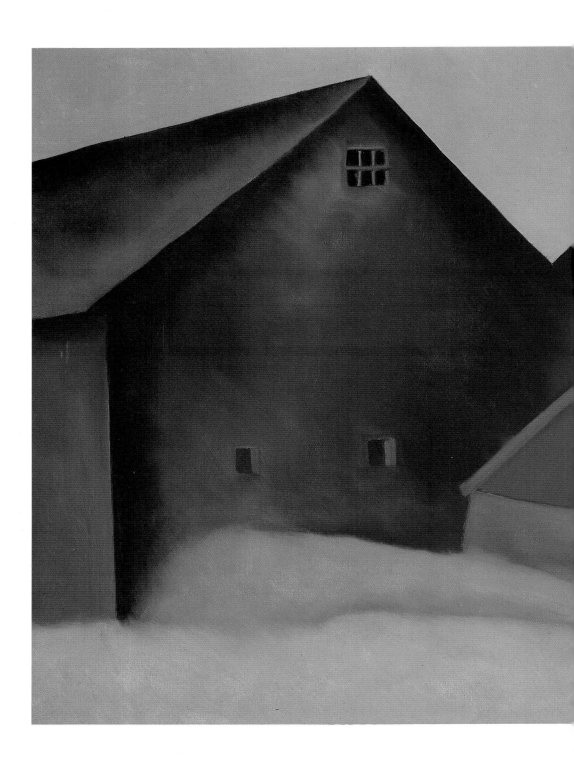

Ends of Barns

1922, oil on canvas; 16 x 22 in. (40.6 x 55.9 cm).
Gift of Mr. And Mrs. William H. Lane,
Juliana Cheney Edwards Collection, Emily
L. Ainsley Fund, and Grant Walker Fund,
Museum of Fine Arts, Boston, Massachusetts.
Of her early years with Stieglitz
in New York, O'Keeffe told Anita
Pollitzer, ". . . I had so much to
work out that I had started on at
the [Texas] ranch, and in New York
I went on working." "New York,"
of course, included the Lake George
area, where she painted these barns.

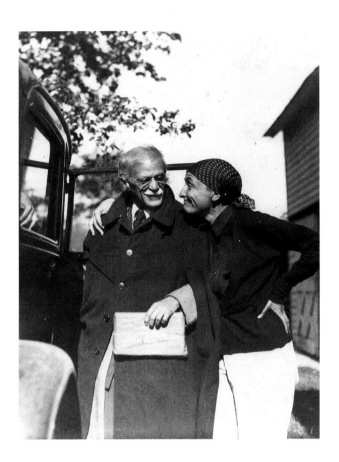

Stieglitz and O'Keeffe at the Door of Georgia's Model A Ford

UNKNOWN PHOTOGRAPHER, 1932.

The Beinecke Rare Book and Manuscript Library,

Yale University, New Haven, Connecticut.

This photograph was taken during one of the couple's most difficult periods, while at their house on the Hill at Lake George. O'Keeffe is uncharacteristically mugging for the camera as she bids good-bye to Stieglitz, while her husband regards her with an incredulous expression.

The White Calico Flower

1931, oil on canvas; 30 x 36 in. (76.2 x 91.4 cm). The Whitney Museum of American Art, New York.
By the 1920s O'Keeffe had become one of the most famous artists in
America due to the popularity of her dramatic paintings of gigantic
flowers, which magnified their subjects in a new and startling fashion.

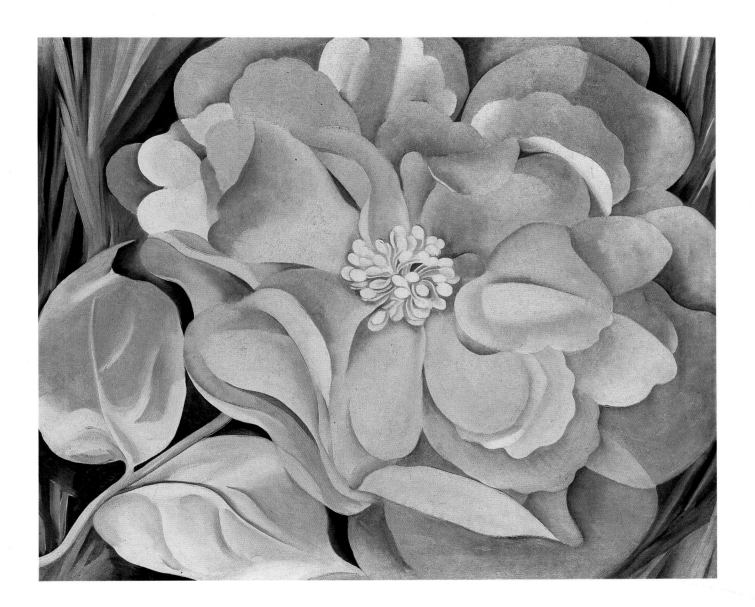

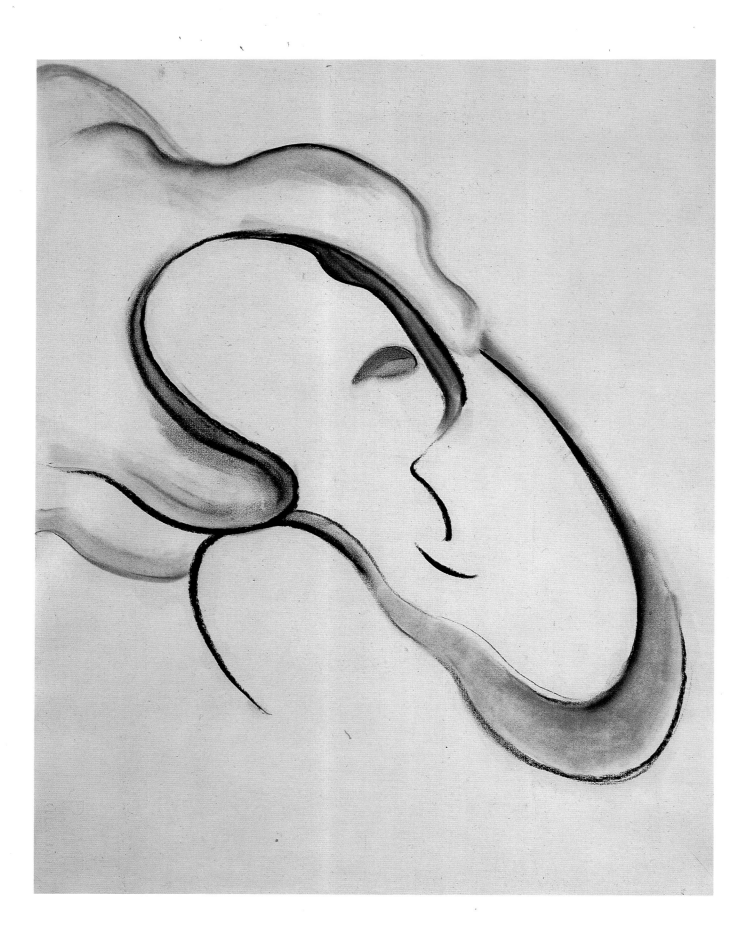

THE NEW YORK DECADE, 1918–1928

O'Keeffe's early, impromptu thrust into the New York art scene as a painter was due largely to the patronage of Alfred Stieglitz.

Born in 1864, in Hoboken, New Jersey, Stieglitz was by the time he met O'Keeffe a prominent photographer and an ardent promoter of contemporary art. In 1905 he had opened the Photo-Secession Gallery at 291 Fifth Avenue in New York City, and the attic gallery became known simply as 291. Stieglitz made it his crusade to show both American and European contemporary art, and he exhibited this work at 291 even before the renowned Armory Show brought European artists of the time to the American consciousness. Thanks to Stieglitz, many young American artists were able to see some of the newest art being produced.

In 1908 O'Keeffe went with fellow students to see the Rodin exhibition at 291. The instructors at the Art Students League had urged the students to go in order to see an example of the sort of art that could not be taken seriously. O'Keeffe felt differently about the invigorating atmosphere at the gallery, where artists would gather to talk and work and critique each other's paintings. In 1915 she wrote to Anita Pollitzer: "The last time I went up to 291 there was nothing on the walls . . . and talk behind the curtain. I even liked it when there was nothing."

Abstraction IX

1916, charcoal on paper; 24 1/2 x 18 3/4 in. (62 x 48 cm).

The Alfred Stieglitz Collection, The Metropolitan Museum of Art, New York.

By 1916 O'Keeffe, a portraitist from an early age, was able to reduce the likeness of her fellow student and friend Dorothy True to a few essential forms. The swirling lines represent the ever present cigarette smoke surrounding Dorothy, yet this composition also displays the simple series of curves and shaded planes representative of the painter's other early abstractions.

While away at her teaching posts O'Keeffe received regular bulletins from Anita Pollitzer about exhibitions at 291. Pollitzer would regale her friend with second-hand impressions of the art she had seen, and the reproductions one could obtain of contemporary European art. Since Pollitzer was a regular visitor to the gallery, it was not surprising that she turned to Stieglitz for a professional opinion on O'Keeffe's latest works. O'Keeffe herself said in a letter of October 11, 1915: ". . . I believe I would rather have Stieglitz like something—anything I had done—than anyone else I know of . . ."

Stieglitz's support of the unknown artist was instant and wholehearted. Stieglitz recognized in O'Keeffe's early abstractions the expressiveness that would fill her work throughout her life. Though it was only a few years after the first major Russian experiments in abstract expressionism, O'Keeffe was already producing totally abstract drawings and watercolors. Most, such as *Abstraction IX*, were based on a simple series of lines and curved shapes.

O'Keeffe's first encounter with Stieglitz was indicative of the self-assured artist. When Stieglitz asked her if she knew what she'd done in her drawings, she reportedly replied, "Certainly I know what I've done. Do you think I'm an idiot?" Yet O'Keeffe was not able to convince Stieglitz to remove her drawings from his gallery walls. She considered her drawings to be private and personal, and was uncomfortable with exhibiting them.

O'Keeffe then traveled to Texas for a second time, becoming the head of the art department at West Texas State Normal College in Canyon, Texas (a post she held from 1916 to 1918). Her aesthetic sense was again stunned by the region's wide-open spaces, which inspired a new sense of freedom in her work.

She painted the sunlight falling on the vast planes at various times of day and enjoyed harmonizing

strident colors, using the force of her hues to convey the full impact of a spectacular sunset or sunrise. Her watercolors were rich with pigment, as can be seen in her imaginative rendering of the sky in *Evening Star III*. She even experimented in how far to separate the strokes in order to keep the tints pure.

It was during this prolonged stay in Texas that O'Keeffe read Russian painter and theorist Wassily Kandinsky's *Concerning the Spiritual in Art*, underlining and memorizing passages. In the spirit of Nietzsche, Kandinsky believed that artists were the true spiritual guides of their age. Kandinsky maintained that the artist's "eyes should be always directed to his own inner life."

Meanwhile, Stieglitz continued to exhibit O'Keeffe's work in New York, first in a group exhibition at 291 and then in a solo exhibition in April of 1917. This resulted in her first sale, and it was at this time that Stieglitz first photographed O'Keeffe, posing her against the walls of her own exhibit.

Critics praised highly O'Keeffe's first shows at 291, calling her work innovative. Her abstracts were described as sincere and beautiful because of their uniqueness. Art critic William Murrell Fisher said in the June 1917 issue of *Camera Work*: ". . . Quite sensibly, there is an inner law of harmony at work in the composition . . . most are but fragments of vision, incompleted movements, yet even the least satisfactory of them has the quality of completeness . . ."

In 1918 Stieglitz managed to convince O'Keeffe to give up her teaching post in Texas and return to New York in order to paint. Stieglitz was twenty-three years older than O'Keeffe, who was then a thirty-year-old school teacher. In that era she might have been considered an old maid, yet the O'Keeffe family had never been one to emphasize marriage to their daughters.

O'Keeffe had obviously had enough of struggling to create her art, and so accepted Stieglitz's offer of financial support for "a year to paint." But one year turned into several decades as Stieglitz continued to provide financial and professional support for

O'Keeffe, giving her the artistic environment she needed to flourish. Acquaintances say that the attraction between the two artists was immediate, though they didn't marry until six years later, in October of 1924.

When O'Keeffe relocated to New York, she was immediately swept into the turbulent art world that followed World War I. Though Stieglitz had to close 291, he continued to be a focus of intellectual exploration for the contemporary artists of America. The couple were often accompanied by friends and artists in their annual cycle of winters spent in Manhattan and summers at Lake George in upstate New York.

O'Keeffe painted all day, living and working on the top floor of a brownstone on Fifty-Ninth Street. When Stieglitz came home, they went out to dinner, ". . . usually to the little restaurant on Columbus Circle where his group of artists knew they could find him and where the art talk could go on for hours."

According to Pollitzer, O'Keeffe did not join in the debates over art. She believed ideas were personal, and so kept them to herself. Stieglitz considered O'Keeffe to be an "innocent," defining her as one ". . . who does not explain, for whom life is both a mystery and a total light, one who does not complain . . . The innocent one assumes all responsibility . . ." O'Keeffe preferred to trust her aesthetic intuition rather than indulge in intellectual theory.

ABSTRACTIONISM

Innovative is a description that was repeatedly applied to O'Keeffe's work. Her watercolors and oils were like nothing else that was being done in contemporary American art in the 1920s. O'Keeffe took that as a matter of course—she had always crusaded for a more discriminating approach toward self-expression, and also taught art by that principle.

Though her own years of training had been devoted to copying Old Masters, she had always questioned that practice, asking why it was necessary to copy paintings so great they could never truly be reproduced. During her self-evaluation, she had realized

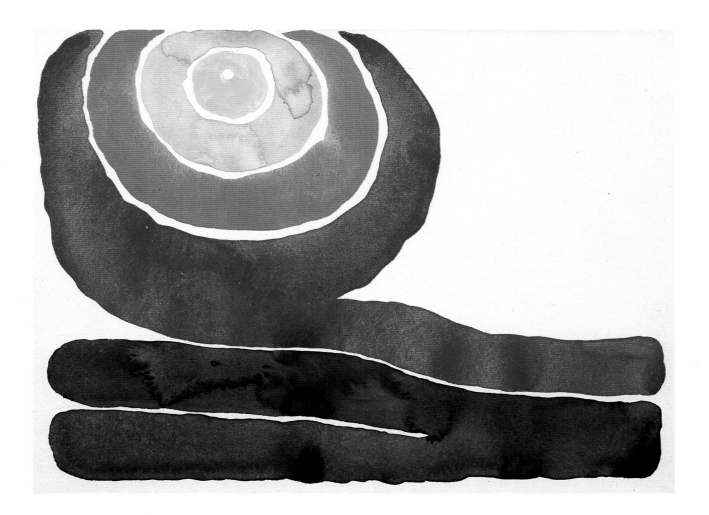

Evening Star III

1917, watercolor on paper; 9 x 11 7/8 in. (23 x 30 cm). Mr. and
Mrs. Donald B. Straus Fund, The Museum of Modern Art, New York.
O'Keeffe created a series of ten watercolors based on
Texas sunsets. Beginning with pale washes that blended
one into another, she gradually heightened the intensity of
the color until the entire paper was saturated with pigment.

that masterpieces are direct expressions of great
artists and the lives they led. She intended for her own
work to be as original and powerful.

O'Keeffe acknowledged the practice it took to
develop a personal style. Like many other modern
artists, she usually did a series of paintings on the
same subject, exploring the physical complexities of
an object in order to render it in more subtle ways.
Gradually, she reached toward molding the patterns
and shapes through gradations of color rather than
line. And instead of devoting her time to one large-
scale painting, O'Keeffe found that her ideas could be
worked out in groups of smaller paintings.

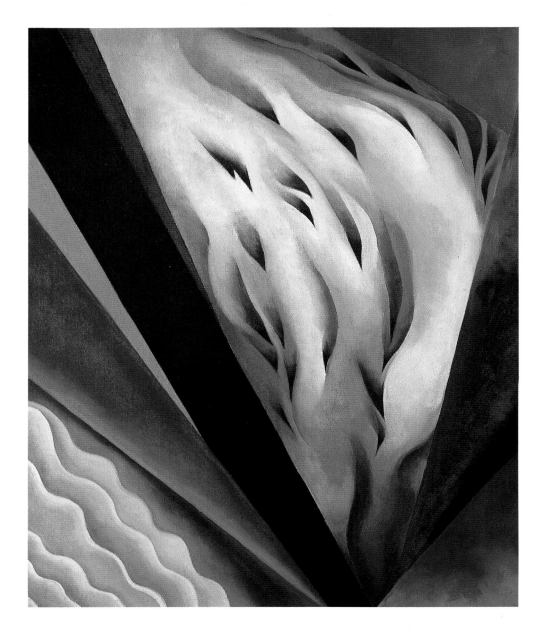

Blue and Green Music

1919, oil on canvas; 23 x 19 in. (58 x 48 cm). Gift of Georgia
O'Keeffe, 1969.835, The Art Institute of Chicago, Chicago, Illinois.
This composition illustrates O'Keeffe's attempt to convey
sound through a radiated burst of waving lines. During one
of O'Keeffe's exhibits at Stieglitz's gallery, the critic William
Fisher praised her "mystic and musical drawings," which
he likened to religious revelations in their cosmic grandeur.

In 1919 she began a series of oils based on her recent Texas watercolors. In these works, her abstractions had evolved from the hard angles of her charcoal drawings to the more organic lines inspired by the southwest.

Color was a primary area of exploration, as she discovered she could evoke moods and impressions through her palette. O'Keeffe's colors harmonize despite the brilliant, varying hues that glow like jewels on the canvas. Ruby reds, violets, and emerald greens shade into startling orange and yellow; frosty blue-white streaks split space, interspersed with patches of dense pure white as steady as light itself.

Like other Stieglitz artists, O'Keeffe believed she could represent sound through her art. But her works based on musical themes date from the years before she was exposed to the daily discussions of the art world. On a trip with her sister through the wilds of Colorado in 1916, O'Keeffe wrote to Anita Pollitzer that she wanted "more than ever" to write music.

She painted three canvases in 1919 based on the theme of music. *Music: Pink and Blue* is a highly organic view of music, as if sound is rippling through the sky. Rayed bursts of color are interspersed with organic lines that capture the harmony and flow of

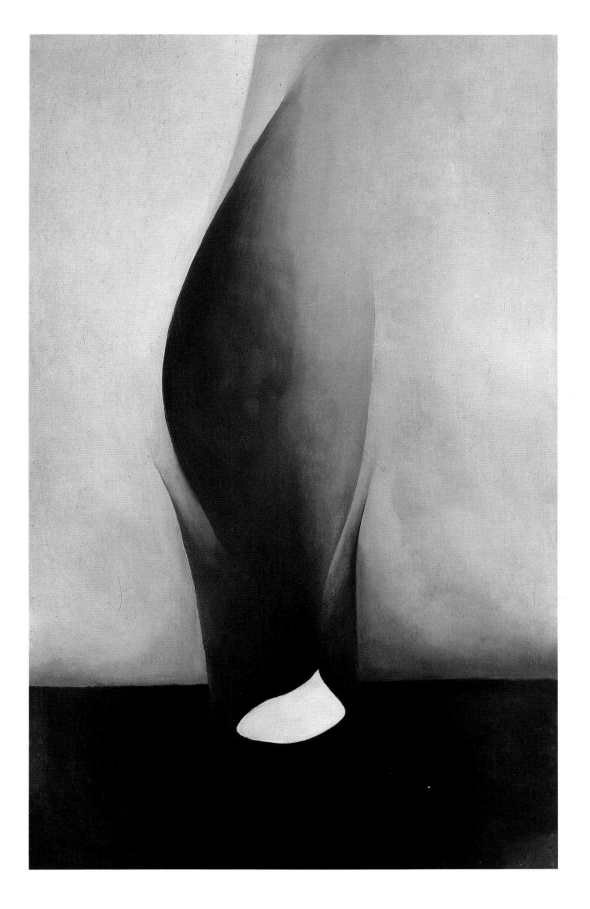

Shell and Shingle VI

1926, oil on canvas; 30 x 18 in. (76 x 46 cm). Gift of Charles E. Claggett in Memory of Blanche Fischel Claggett, The Saint Louis Art Museum, St. Louis, Missouri. O'Keeffe's skillful reduction of her subjects reflected painter and theorist Wassily Kandinsky's search for "manifestations of life" through vibrations and mystically derived patterns. Both artists were employing abstractions as a means to discover the formative basis of all material shapes.

O'Keeffe's 1923 Exhibition
at Anderson Galleries, New York

ALFRED STIEGLITZ, 1923; photograph. Mitchell Kennerly Papers,
The New York Public Library, Astor, Lenox and Tilden Foundations, New York.
In 1923, Stieglitz presented one hundred of O'Keeffe's
pictures at the Anderson Gallery on Park Avenue, where he
had been offered exhibition space after 291 closed its doors.

the notes on canvas. *From the Plains* can be seen as a
horizontal variation on this abstract theme.

Even this early in her career, O'Keeffe was gravitat-
ing toward naturally inherent patterns. By focusing
on fundamental lines, she found she could remain
constant to the essence of the object, even in abstract
renderings. She often painted fragments of things
because it seemed to make her statement as well as or
better than the whole.

Throughout her career, O'Keeffe attempted to dis-
till objects into their essence. She wanted to convey
through line and color a reflection that was pure,
intense, and as direct as life itself. Her early abstrac-
tions were attempts to create a formal language for
the pure expression of nature, and she found the basic
patterns of nature in bud-shaped forms, vertical rayed
bursts, and organic spirals. When she turned her rare
vision (developed especially during her magnification
of flowers) on other objects, such as shells and leaves,

O'Keeffe found repeating patterns within different
subjects. In her painting *Shell and Shingle VI* (1926),
for example, the viewer will discover there either a
flower or a shingle.

O'Keeffe's work calls to mind the complex, repeat-
ing rhythms found in nature. Just as ancient Indian
hieroglyphs of the southwest pictured the eternal spi-
ral of life, and current scientific renderings reveal
genetic codes carried on spiral DNA, O'Keeffe
invested in her own conception of the natural world
and created works that resonate with the creative
power of life itself.

In all of her work, O'Keeffe utilized her emotional
response to reality as the basis for her renderings.
One example was the impact of World War I, during
which her brother Alexis was killed in the trenches on
the western front by deadly clouds of gas. In
Abstraction—Alexis (1928) this monumental event is
encompassed by clouds of destruction, while the
vibrating, wounded pink lines near the bottom per-
haps represent O'Keeffe's grief at the loss of her
brother.

When dealing with something so subjective as a
personal response, critics unfortunately can have a
field day coming up with possible meanings. This was
certainly true in O'Keeffe's case, and she soon found
that critics began to review her flower paintings in the
same terms that they used to examine Stieglitz's pho-
tographs of her body.

Even so O'Keeffe's 1923 exhibition at the Anderson
Galleries was visited by five hundred people a day,
according to the *New York Sun*. She was growing in
popularity as both a personality and as a respected
artist. Henry McBride, from the *New York Sun*, was
one of the first critics to offer unqualified praise to
O'Keeffe: ". . . we have peace in the present collection
of pictures. There is a great deal of clear, precise,
unworried painting in them."

Abstraction Blue

1927, oil on canvas; 40 1/4 x 30 in. (102.1 x 76 cm). Acquired through
the Helen Acheson Bequest, The Museum of Modern Art, New York.
The pointed shaft sharply divides this composition,
yet the soft focus of the color suggests clouds and
landscape. O'Keeffe's abstractions from the 1920s
often reflect Stieglitz's photographic series of cloud
and landscape elements, which he called his "Equivalents."

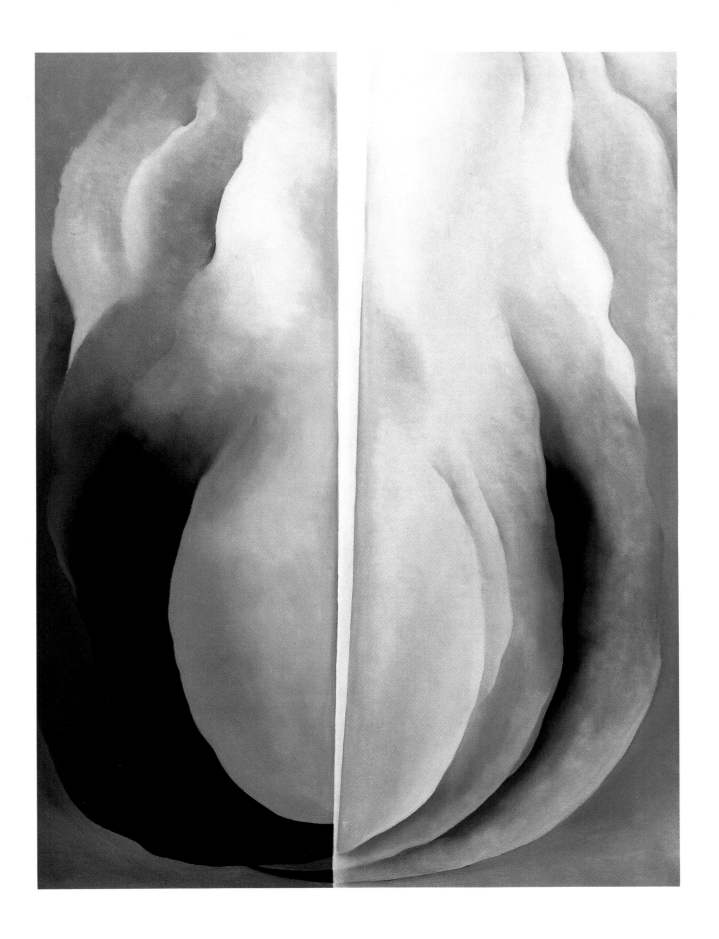

LAKE GEORGE LANDSCAPES

Summers spent at Lake George, about two hundred miles north of New York City, offered O'Keeffe an annual creative renewal. Stieglitz's mother had a large house on the shore of the lake, situated in the heart of the pine- and birch-covered Adirondack Mountains, where the Stieglitz clan along with artists and friends who were summer visitors gathered year after year.

According to Georgia Engelhard, Stieglitz's niece, the couple remained outside all day, walking or rowing, with ". . . Georgia painting like mad, and he photographing." Stieglitz showed O'Keeffe every photograph he developed, and she helped him sometimes in his work. O'Keeffe credits Stieglitz, saying, ". . . he would notice shapes and colors different from those I had seen and so delicate that I began to notice more."

**Red Hills, Lake George
(The Red Hills with Sun)**

1927, oil on canvas; 27 x 32 in. (69 x 81 cm).

The Phillips Collection, Washington, D.C.

Margaret Prosser, a long-time family servant, credits O'Keeffe for inspiring Stieglitz's photographs of the 1920s, which focused on nature—clouds, the moon, even lightning—images he had never before photographed. This image shows one of the many vistas O'Keeffe opened up to his inquiring eye.

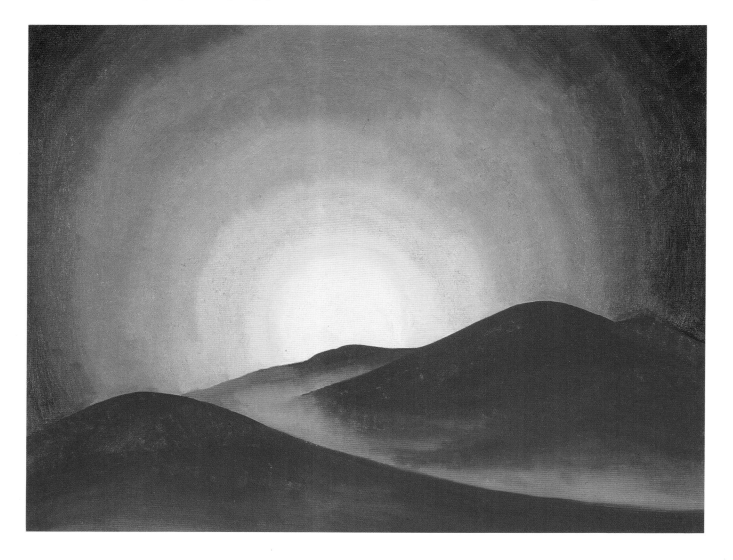

One of the long-standing servants who cared for the family during their stays at Lake George said of O'Keeffe: "I never knew anyone who could do so many things so well." O'Keeffe was a thorough housekeeper, and, according to Stieglitz, enjoyed experimenting when she cooked. But her meticulous nature caused her to be a perfectionist, a state difficult to maintain in the midst of such a large and noisy group.

In her search for simple, elegant truth, O'Keeffe was as ever a unique presence. At Lake George, when she had to go out to social functions, she would wear a simple white dress and flat shoes, while the other women put on frills and flower bouquets, toting their parasols, sweeping hats, and long gloves. Anita Pollitzer commented that O'Keeffe's reserved style of dress was different from everyone else's from the first moment she came to New York in 1914, wearing neat coat-suits and crisp white blouses.

O'Keeffe apparently made the transition into the tightly-knit Stieglitz clan with the strong support of Stieglitz's mother—despite the fact that Stieglitz did not obtain a divorce from his first wife until 1924. One of Stieglitz's brothers, Dr. Leopold Stieglitz, was a physician, while Julius Stieglitz, another brother, was the head of the Department of Chemistry at the University of Chicago. Often the debates turned to art, and, according to Engelhard, during Stieglitz's general discussion of O'Keeffe's current works, she would act "polite, and speaking only when she was spoken to—as detached as though she had nothing to do with the painting."

It was in Lake George where O'Keeffe realized even more strongly that it was not only the form of a subject that mattered, despite the fact that this was the only thing her art teachers had ever emphasized. She understood that for a thing to be painted well, the artist's feelings about the object must be expressed in addition to the object itself. A landscape could be gloomy or cheerful, depending on how the artist herself chose to reflect her own feelings. O'Keeffe often said she rendered natural objects as equivalents for her experience of a place.

Helen Read, reviewing O'Keeffe's 1924 exhibition, concluded with the comment, "Each picture is in a way a portrait of herself." Stieglitz also used to remark on O'Keeffe's tendency toward self-portrayal, particularly in her still lifes. She sometimes created

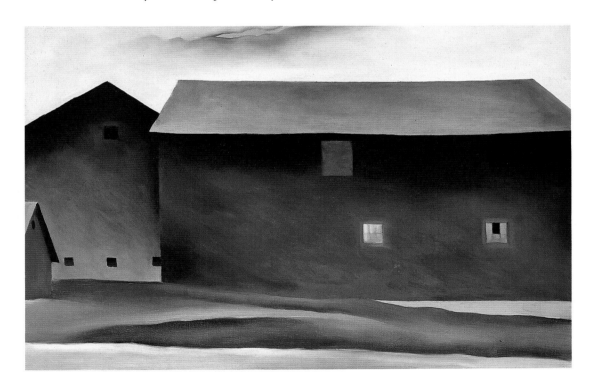

Lake George Barns

1926, oil on canvas; 21 3/4 x 32 in. (55 x 81 cm). Gift of the T. B. Walker Foundation, 1954, Collection of the Walker Art Center, Minneapolis, Minnesota.
Art critic Henry McBride wrote in the *New York Sun*, January 14, 1933: ". . . the solidity of these edifices patiently built of tenderly pure pigment is something I do not understand . . . That's why I say the best O'Keeffe's seem wished upon the canvas—the mechanics have been so successfully concealed."

portraits of others as well, as in *Birch and Pine Trees—Pink* (1925), which she referred to in a letter as ". . . a painting I made from something of you the first time you were here."

Throughout her life, O'Keeffe scavenged through nature to find inspiration. Real, physical objects were the basis of her abstract renderings, as she attempted to convey sound, sensation, and her exhilaration in the face of the natural world. Her strange and brooding images also evoke feelings of growth, renewal, and permanence in nature. *From the Lake No. 3* (1924) takes the autumn greenery to abstract heights, rendering the vibrancy of the moving water through chips of blue-white light and ripples of verdant green and tawny gold.

Though the contemporary art scene generally disdained both still lifes and landscapes, O'Keeffe's focus on elements of nature reflects the studies of other artists at the time. Within the Canadian Group of Seven, for example, artists were trying to find "a true racial expression" by capturing the mood of their own land rather than looking back to a European heritage.

O'Keeffe also tried to express personal meaning and significance through her work. For her, the numerous studies of barns she painted in the Lake George region were "healthy" midwestern symbols and reminders of her happy childhood. Stieglitz, too, photographed barns, and was known to be possessive of his particular favorites. Since the subject of barns was a highly personal one for O'Keeffe, some critics have surmised that her variations on this subject reflect her moods in relation to the conflicts of her life with Stieglitz.

My Shanty, Lake George (1922) is a rendering of the small, run-down building that had been converted into a studio for Stieglitz and O'Keeffe, but O'Keeffe soon appropriated the place for her own private retreat in the midst of the large Stieglitz clan. The dark colors in this painting are unusual for O'Keeffe, and reflect the palette of her fellow modernist Marsden Hartley at that time. She says she was inspired by the thought of working on a "dismal-colored" painting like "the men." The fact that she chose her personal retreat as the subject is an intriguing comment.

The artist painted her last barn in 1934, when she was emerging from perhaps the most trying time of her life, following a three-year hiatus from painting. The Wisconsin barn is blanketed with a layer of snow—as if in hibernation. O'Keeffe did not enjoy her return to the Wisconsin countryside, and this cemented her desire to return to the southwest.

During the New York decade, O'Keeffe also returned to her studies of still lifes. William Merritt Chase, of the Art Students League, had insisted that his students create a new still life every day. At the end of the week, he would critique the group of studies.

This energetic production would inevitably lead to a sketchy style—much different from O'Keeffe's meticulous renderings of apples, leaves, and trees during the 1920s. Yet the speed needed to complete the task forced the young artist to look for the essentials, training her to seek out and quickly capture the image of the object. As a result, when O'Keeffe began painting apples around 1920, she abandoned the traditional, realistic still-life setting and placed the plate and apple on a white void. By isolating the subject, the viewer is forced to look at the objects themselves rather than their relation to their surroundings.

O'Keeffe's still life arrangements of apples and leaves, however, remained highly structured, using color and expressive brushwork to convey their natural, realistic vitality. The series of apple paintings and the early leaf paintings were painted on small canvases, mirroring her tight, meticulous focus on the details. Her apples were sometimes jumbled together, or gathered in a basket, yet her compositions emphasized organic rhythms, echoing the individually rendered shapes. She also layered her leaves and gathered them into clusters, eventually focusing in on the twisting, curling edges, and the pattern of veins.

From the Lake No. 3

1924, oil on canvas; 36 x 30 in. (91 x 76 cm). The Alfred Stieglitz Collection: Bequest of Georgia O'Keeffe, The Philadelphia Museum of Art, Philadelphia, Pennsylvania.
O'Keeffe wrote in the announcement for her exhibition of January 1923: "One day seven years ago . . . I decided I was a very stupid fool not to at least paint as I wanted to and say what I wanted when I painted . . ."

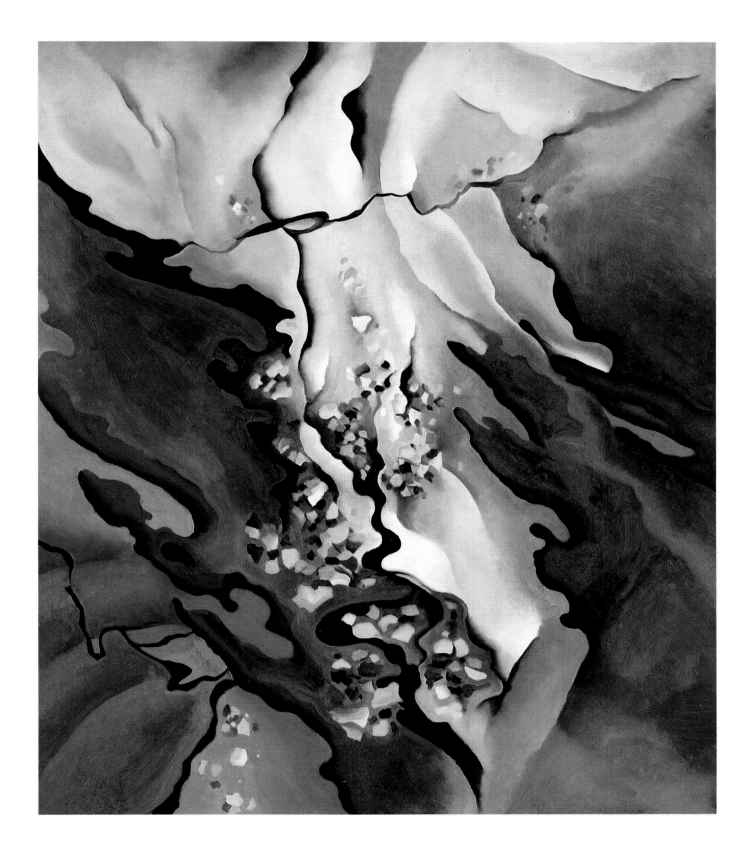

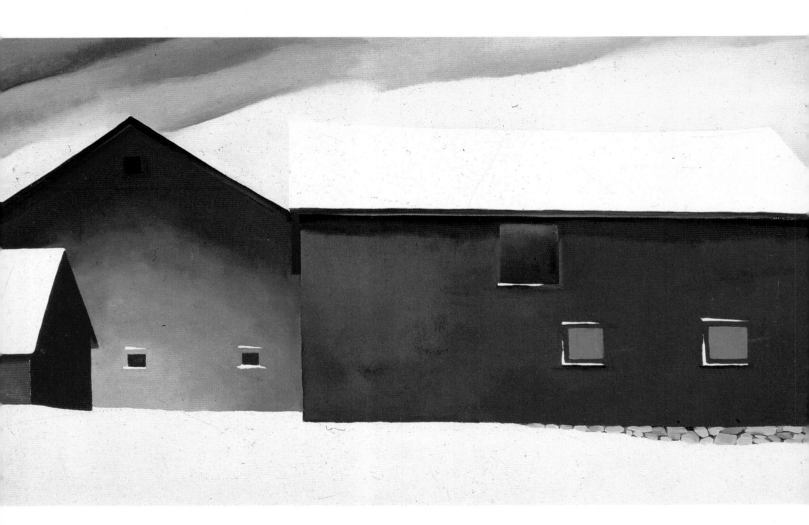

Barn with Snow

1934, oil on canvas; 16 x 28 in. (41 x 71 cm). Gift of Mr. and Mrs.
Norton S. Walbridge, The San Diego Museum of Art, San Diego, California.
This was one of the first paintings O'Keeffe completed while she
was recuperating from a long hospitalization for psychoneurosis.
Fittingly, she chose to paint a barn covered with snow, representing
her own hibernation, as if she and the barn both were lying in
wait for the quickening sun and warmth of a southwestern spring.

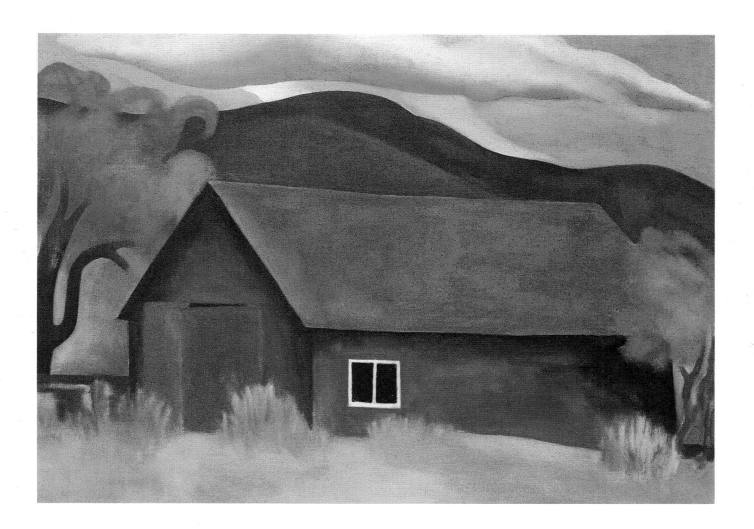

My Shanty, Lake George

1922, oil on canvas; 20 x 37 in. (51 x 94 cm).

The Phillips Collection, Washington, D.C.

This is O'Keeffe's only painting of the
humble building at Lake George that had
been turned into her art studio—a place
where she could get away from vacationing
family and friends and just paint.

This focus on detail coincided with an intense concentration on flowers, culminating in the magnification of their shapes in 1923. The next year, O'Keeffe dramatically enlarged her leaf paintings, filling a 36-inch (91-centimeter) canvas with one leaf. Rather than attempting to achieve a pattern of vitality through many leaves, she focused upon two or three overlapping varieties, creating more static compositions.

Trees too were a subject O'Keeffe explored throughout her entire life. She attempted to simplify her renderings of trees through isolated details of trunk and branches. In early studies, the artist created a cruciform composition that heralded the basic patterns found in her later skyscrapers and flowers. In the mid-1920s, she focused on the smooth bare trunks and branches of the Lake George trees, staying in the area far into autumn after the other summer visitors had left. She usually flattened the recession into space, merging the tree and its surroundings into one another, as in *Autumn Trees—The Maple*.

Later, in the mid-1940s, O'Keeffe would resume her tree studies—this time capturing the cottonwoods of New Mexico. She turned also to the eerily beautiful forms of the dead hardwood trees of the desert, which remained standing long after they had ceased to live. Increasingly, she stripped her trees of any incidental details, preferring their isolated silhouettes against the backdrop of sky, while honing in on the colors within the silvered bark.

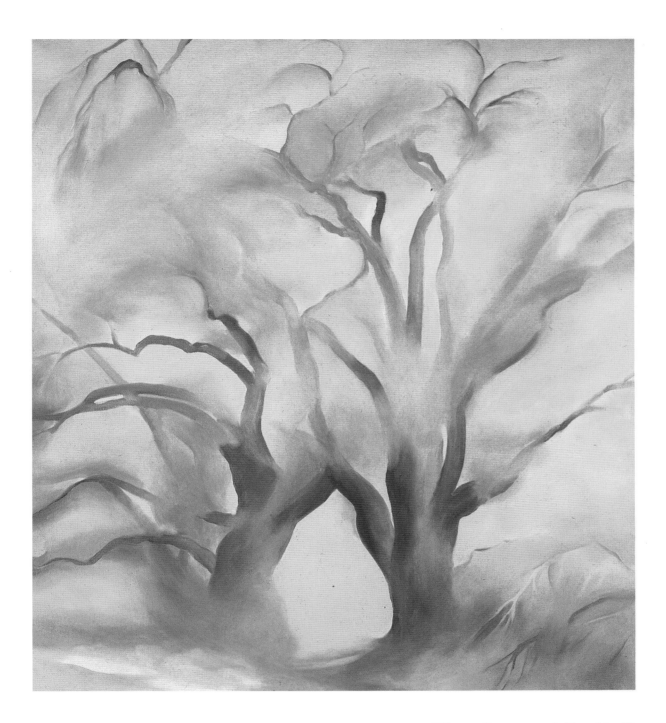

Winter Cottonwoods East No. V.

1954, oil on canvas; 40 x 30 in. (102 x 76 cm).
The Gerald Peters Gallery, Santa Fe, New Mexico.
This study evokes the same patterns as the 1924
Autumn Trees—The Maple. Here, the earlier cool colors
have been replaced with warm and softly silvered hues
that capture the shimmering of light and the sensation
of cottonwood leaves moving unceasingly in the breeze.

Bare Tree Trunks with Snow

1946, oil on canvas; 29 1/4 x 39 1/8 in. (74 x 100 cm).
Dallas Art Association, Dallas Museum of Art, Dallas, Texas.
Though the trees are stripped of their leaves and
are hibernating in the snow, their organic grouping
still creates sensations inspired by the natural world.

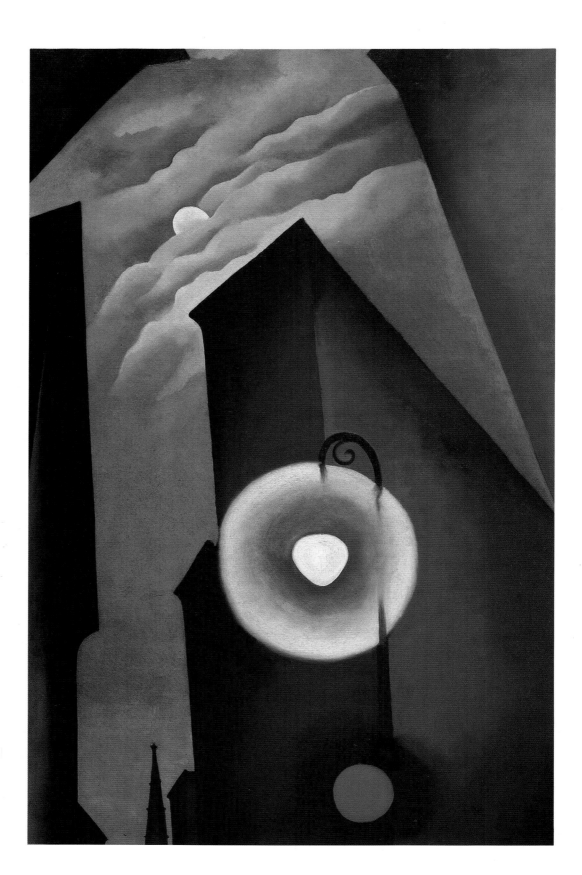

**New York
with Moon**

*1925, oil on canvas;
48 x 30 in. (122 x 76 cm).
Thyssen-Bornemisza Col-
lection, Lugano, Switzerland.*
Stieglitz was reported-
ly unhappy with
O'Keeffe's desire to
paint New York City,
but she was determined
to capture the essence
of the growing metro-
polis. Painting the
patterns that she saw
around her was one
way the artist managed
to come to terms
with living in the city.

NEW YORK SKYSCRAPERS

O'Keeffe and Stieglitz were artists who were inspired by their environment, and for half of every year their environment was the city of New York. Consistently producing works of both the Lake George region and the cityscape, O'Keeffe found the inherent rhythms in each.

Without her primary inspiration of nature, O'Keeffe responded to the organic growth of the city around her. From 1918 to 1930, O'Keeffe painted at least two dozen scenes of New York. The pictures in these series seem to push for wider and wider vistas, as if the artist was trying to break through the bustle of the city to find the underlying universals she so yearned to express. The city, though, gave her a geometric structure as a pattern base. O'Keeffe played with these hard edges and contrasting planes of colored light, finding abstract patterns in the skyline and even in the electric signs that glowed in the night.

The early New York scenes are rendered from a pedestrian point of view. Her first urban painting, *New York with Moon*, was created in 1925. Here, the endless sky is sharply cut by dark angles, as if every pinch of cloud-filled void was precious enough to capture, while the bright streetlight below competes with the light from the sky as a distracting and constant presence. Within this work's somber mood is the underlying construction of split verticals and mirrored fragments—a pattern she found so often in nature.

Her cityscape works have sometimes been called austere and harsh, but O'Keeffe was once more attempting to capture the border between the finite and the infinite by emphasizing the edge between sky and man-made edifice. Space became a key concern to her, and her canvases seem to stretch so as to be limited by no boundaries. Her desire to convey the essence—that which is not directly seen—lent her work an air of great mystery, and suggested that even at this great depth, something else lay beyond.

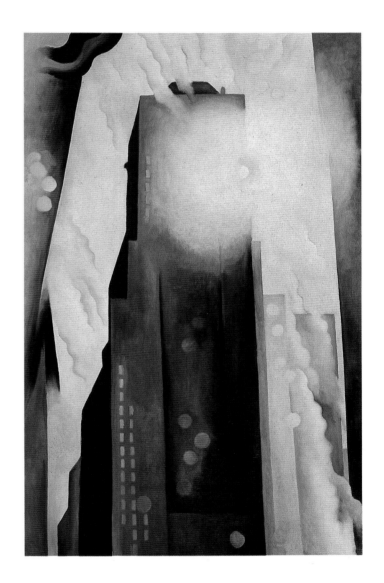

The Shelton with Sunspots,

1926, oil on canvas; 48 1/2 x 30 1/2 in. (123 x 77 cm). Gift of Leigh B. Block, 1985.206, The Art Institute of Chicago, Chicago, Illinois. The East River paintings were first shown to the art world in an exhibition at Stieglitz's Intimate Gallery in January of 1927. Lewis Mumford reviewed the show in the *New Republic* on March 2, saying ". . . her recent work leaves one wondering as to what new aspects of life she will make her own."

In late 1925 O'Keeffe and Stieglitz moved to an upper floor of the Shelton Hotel. It was the first set-back skyscraper in New York, and from the windows O'Keeffe suddenly had a bird's-eye view of the patterns of the city.

The series of East River paintings were quite different from the organic forms of the flowers for which she was quickly becoming famous. In these images she created a realistic interpretation of the industrial skyline of Queens, an outer area of New York City. The compositions flowed on horizontals, unified by the slash of the East River, unlike the skyscraper studies which stretched energetically to the vertical.

Both O'Keeffe's realism and her choice of the city as her subject matter disturbed some of the other artists in Stieglitz's circle. The skyscraper was seen as a uniquely American form of architecture, as something progressive and reflecting the capabilities of man. Some of the other (male) artists in Stieglitz's "Seven Americans" exhibition at the Anderson Galleries in 1925 went so far as to tell O'Keeffe to "leave New York to the men."

Her fellow artists needn't have felt threatened. While the contemporary realists were attempting to capture the exact surface of their subjects, illuminating the contrasts and conflicts in the American scene, O'Keeffe was searching for the emotional simplification of form and image, and for a cosmic unity within every subject she painted.

That O'Keeffe's primary source of inspiration was

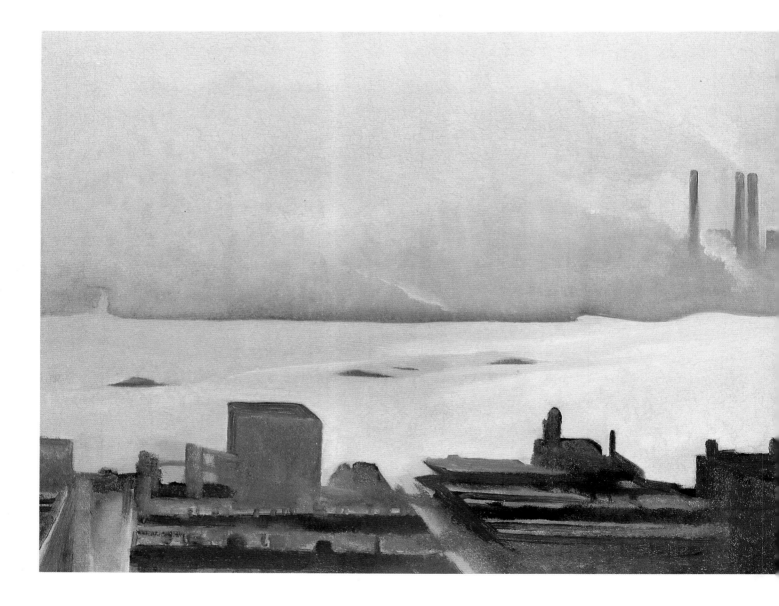

nature is evidenced even in the city paintings. In *The Shelton with Sunspots* (1926), the dominating impression is of the powerful force of the sun. Though only a sliver of yellow peeks around the impenetrable form of the skyscraper, the light and color is cast in such a blinding brilliance that the skyscraper, in this composition, seems insubstantial.

By the late 1920s O'Keeffe began to feel increasingly out of synch with the city. As early as February 1924, she wrote to her sister on the birth of her niece, complimenting her on having a "normal life," something that was impossible for her: "No one in New York can even approach being a normal human being . . . You can be glad that you live in a little town where you can look out and see a tree."

East River Drive No. 1

1926, oil on linen; 36 x 18 in. (91 x 46 cm).
Wichita Art Museum, Wichita, Kansas.
The vast expanse of soot-gray warehouses and factories stretches to the blurry horizon, evoking a melancholy mood. When O'Keeffe began to talk about trying to render the view over the city from their windows at the Shelton, she was told that it was an impossible idea—even "the men" had not done too well with this subject.

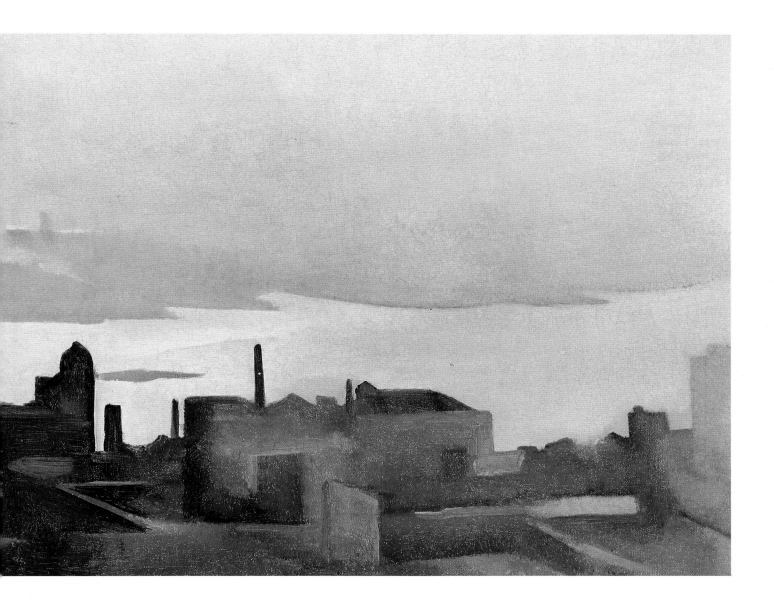

City Night

1926, oil on canvas; 48 x 30 in. (122 x 76 cm). Gift of the Regis Corporation,
N. John Driscoll and the Beim Foundation, the Larson Fund, and by public
subscription, The Minneapolis Institute of Arts, Minneapolis, Minnesota.
This painting shows the reduction of the basic skyscraper
pattern that O'Keeffe painted during the 1920s—its vertical
motifs vibrating with the excitement of the city, while
a somber mood is evoked by the penetrating night sky.

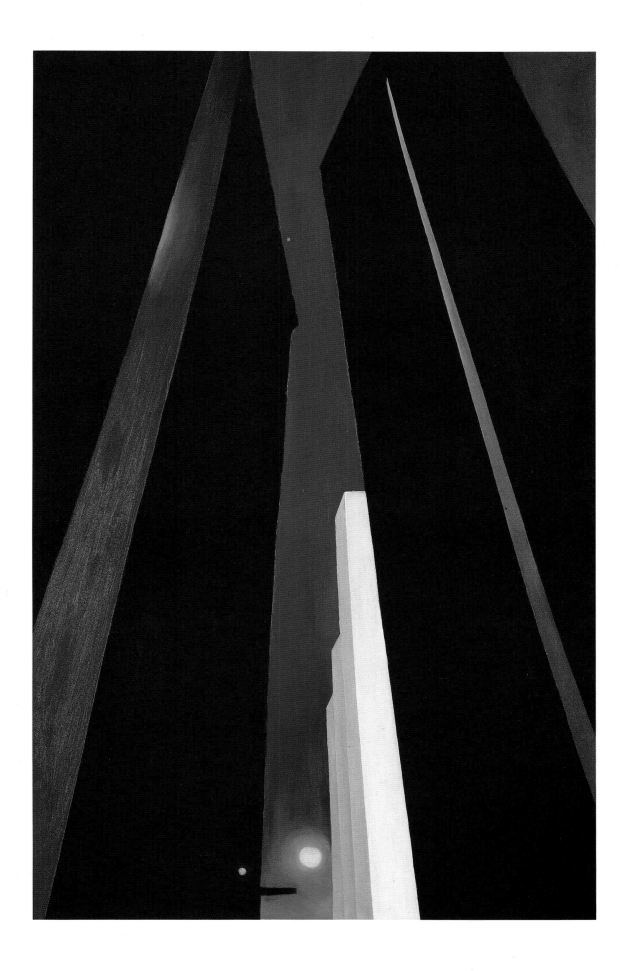

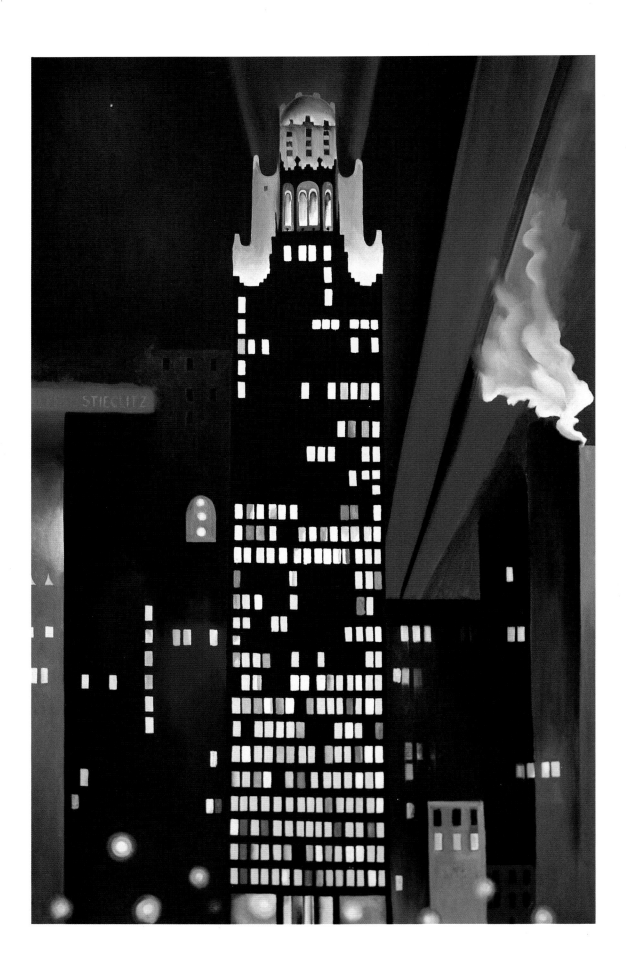

The City of Ambition

ALFRED STIEGLITZ, 1910; photograph.
The Museum of Modern Art, New York.
With the backlighting of the sky-
scrapers, sky and smoke become the
focus of the composition. The mood
of this photograph is echoed by
O'Keeffe's New York City paintings.

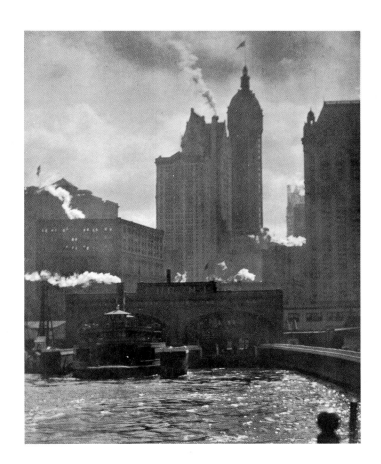

Radiator Building—Night, New York,

1927, oil on canvas; 48 x 30 in. (122 x 76 cm). The Carl Van Vechten
Gallery of Fine Arts, Fisk University, Nashville, Tennessee.
The strong base of the building can be compared to the trees
of Lake George, which O'Keeffe was also painting around the
same time, with rayed light and smoke diffusing the boundary be-
tween earth and sky. Stieglitz's name replaces the real neon sign.

Red and Orange Streak

1919, oil on canvas; 27 x 23 in. (69 x 58 cm). Bequest of Georgia O'Keeffe for the
Alfred Stieglitz Collection, The Philadelphia Museum of Art, Philadelphia, Pennsylvania.
O'Keeffe desired to capture the essence of a landscape through color.
In this painting, the central slash of light draws upon the dazzle of the
last rays of sunlight, while the undulating skyline evokes a sense of
activity over the plains and the sounds of evening in panhandle country.

Alfred Stieglitz, Giving a Lecture

UNKNOWN PHOTOGRAPHER, 1936. Corbis-Bettmann, New York.

On December 2, 1936, at an exhibition of O'Keeffe's work, Stieglitz
gave a lecture to the students of the New York School of Industrial Arts.

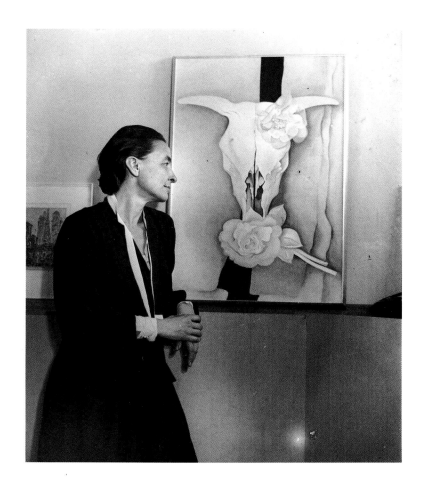

Georgia O'Keeffe

UNKNOWN PHOTOGRAPHER, 1931. The Bettmann Archive, New York.
At an exhibition of her work on December 29, 1931, O'Keeffe
takes a close look at one of her own paintings, *Life and Death*.

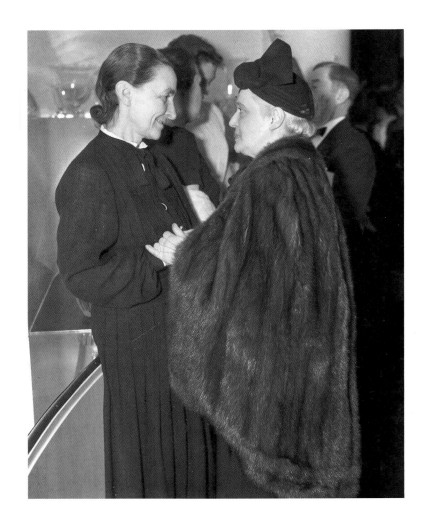

At a Preview

UNKNOWN PHOTOGRAPHER, 1940, The Bettmann Archives, New York.
O'Keeffe and Mrs. Chester Dale, a prominent
art collector, together at a New York preview
of designs in glass, January 24, 1940.

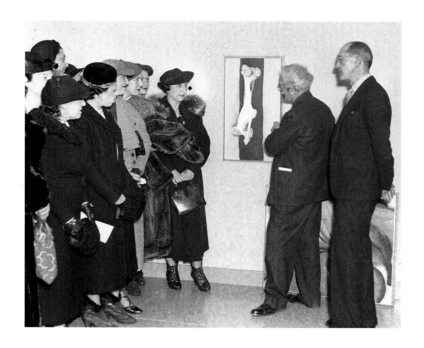

At the New York School of Industrial Arts

UNKNOWN PHOTOGRAPHER, 1936, The Bettmann Archives, New York.
Alfred Stieglitz is shown with Desire Weidinger, the lecturer
for the New York School of Industrial Arts, and a group
of students as they examine O'Keeffe's painting, *The Bone*.

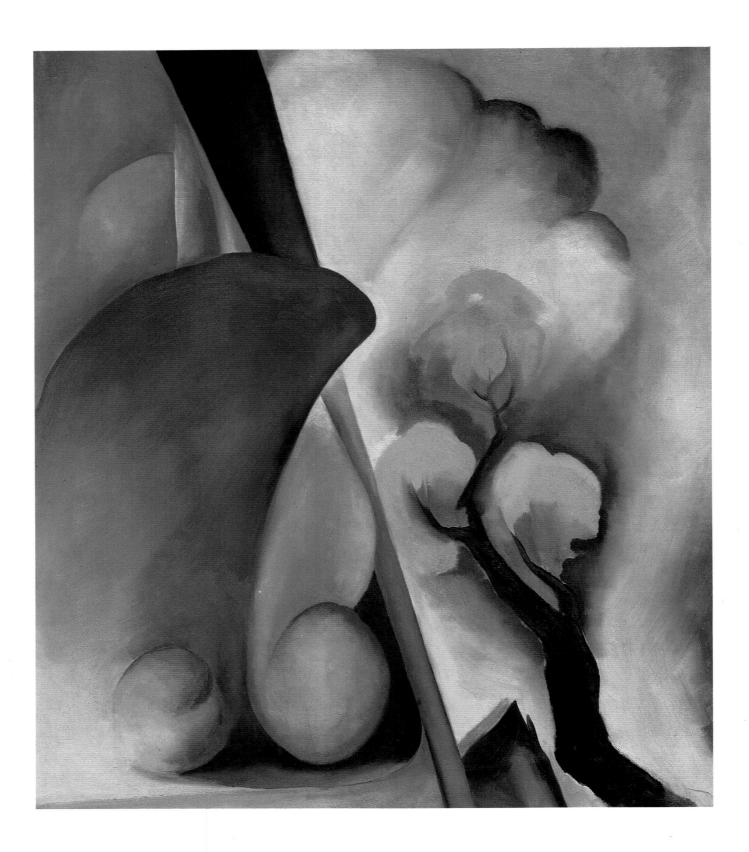

Alfred Stieglitz with Graflex

HEINRICH KUHN, photograph.
The Museum of Modern Art, New York.
Stieglitz is framing a shot deep in
the grass and weeds around Lake
George. The Graflex, a single-lens-
reflex camera producing a much
smaller image than the eight-by-ten
view camera, was used by Stieglitz for
photographs of subjects which needed
to be taken swiftly, such as clouds.

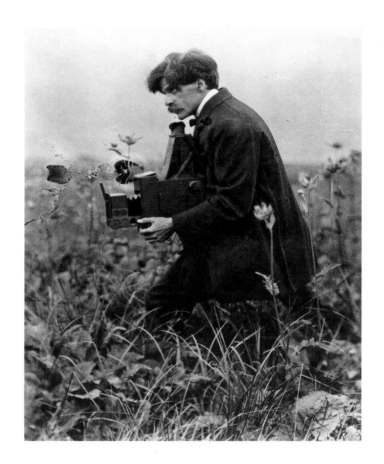

Spring

1922, oil on canvas; 35 1/2 x 30 3/8 in. (90 x 77 cm). Bequest of Mrs. Arthur Schwab (Edna Bryner,
class of 1907) 1967.31.15, Frances Lehman Loeb Art Center, Vassar College, Poughkeepsie, New York.
This stylized design consists of an abstract pattern of simplified organic
shapes. The strong bar of darkness slashing through the canvas is reminiscent
of O'Keeffe's early attempts to evoke movement and sound, while the
rising peak with the burst of white simulates the rhythm of new growth.

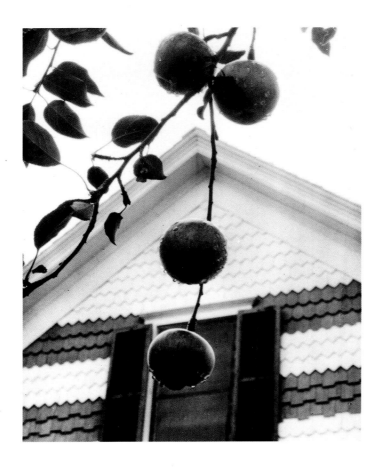

Lake George

ALFRED STIEGLITZ, 1922; photograph.
The Alfred Stieglitz Collection, 1949.728,
The Art Institute of Chicago, Chicago, Illinois.
Stieglitz framed the pointed gable
of the house against the sky, a tech-
nique O'Keeffe would use in her
southwest paintings. Apples were a
favorite subject of both Stieglitz and
O'Keeffe during the early 1920s.

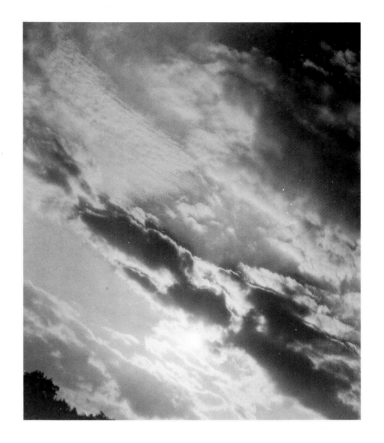

Songs of the Sky

ALFRED STIEGLITZ, 1923; photograph.
The Alfred Stieglitz Collection, The Art
Institute of Chicago, Chicago, Illinois.
The dark cloud mass edged
by light is similar to one of
O'Keeffe's later works, *Celebration*.

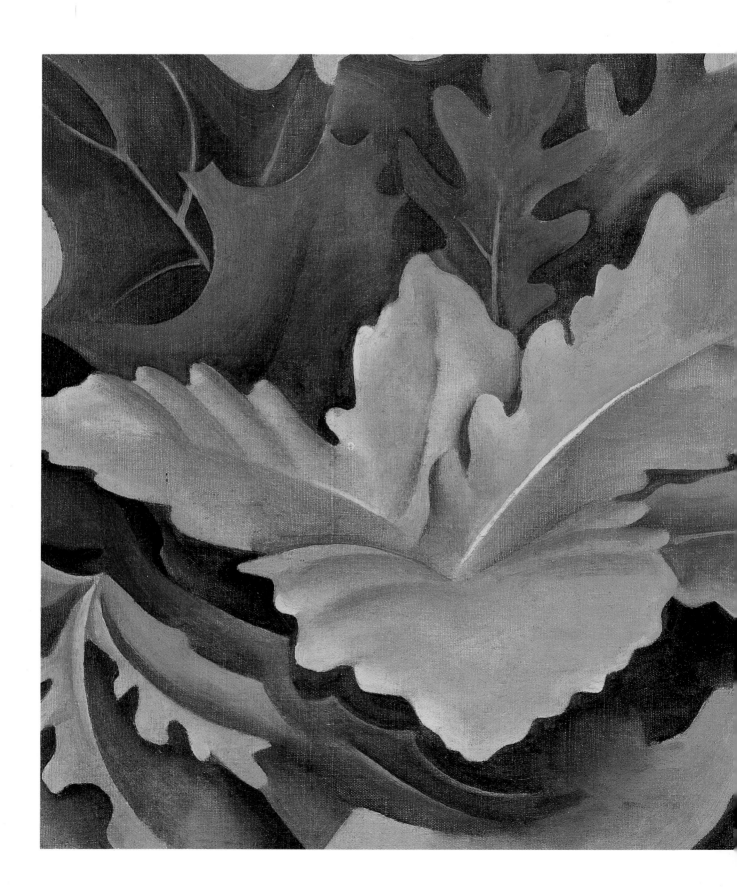

Green Oak Leaves

1923, oil on canvas mounted on wood; 9 x 12 in.
(23 x 30 cm). Cora Louise Hartshorn Bequest 1958,
The Newark Museum, Newark, New Jersey.
Here, O'Keeffe has painted a cluster of oak
leaves, focusing on the sense of pulsing vitality
that is created merely by the irregular outline
and the fine gradations of vibrant green.

Line and Curve

1927, oil on canvas; 32 x 16 1/8 in. (81 x 41 cm). The Alfred Stieglitz Collection,

Bequest of Georgia O'Keeffe, The National Gallery of Art, Washington, D.C.

O'Keeffe constantly wondered if she was successfully conveying what she wanted to through her paintings. As early as 1916, writing to Stieglitz, she asked him what he thought of the charcoals Anita Pollitzer had shown him, saying, "I made them just to express myself—Things I feel and want to say—haven't words for."

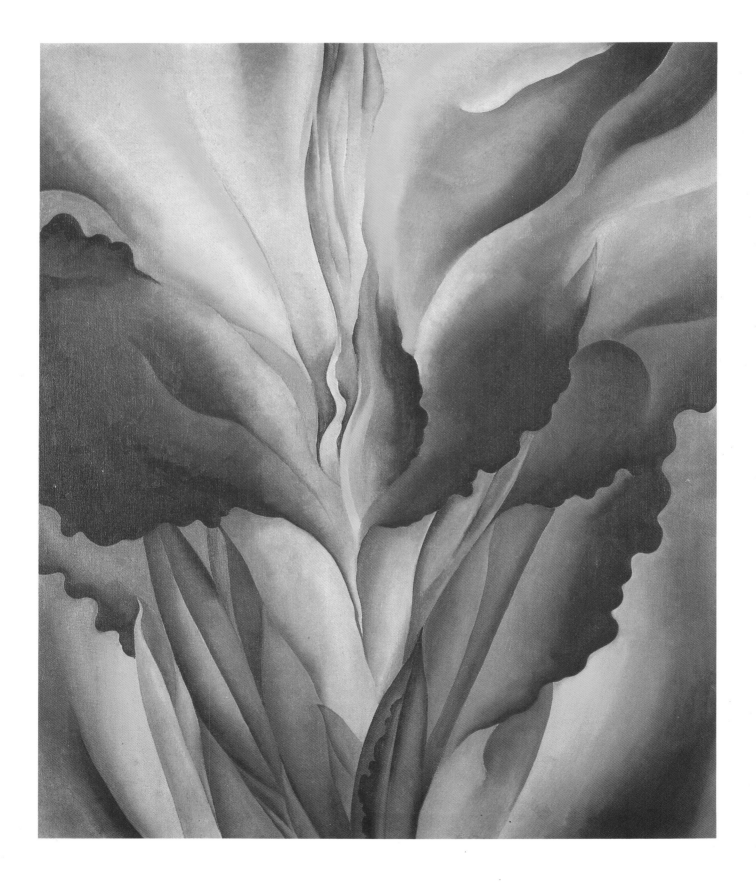

CHAPTER TWO

FLOWERS

By the 1920s O'Keeffe had become one of the most famous artists in America due to the popularity of her dramatic paintings of gigantic flowers: red poppies, black irises, waxy white calla lilies, and velvety purple petunias.

It was particularly difficult for a woman artist to prove herself in the art world at that time. Art critic Alan Burroughs, in the *New York Sun*, praised O'Keeffe's paintings for their "deep, luminous color," and credited her with masculine qualities, while slamming her with the damning statement: "But in this unfair world though the man spends a lifetime in careful consideration of a question, his answer may seem no more sure than the one that the woman gets by guesswork."

Stieglitz naturally continued to promote O'Keeffe's art, comparing her to a force of nature—reflected in her dynamic compositions and the vitality of her colors—while negating her methodical, aesthetic investigation of her subjects. He usually referred to her as a "first-rate artist," believing it unnecessary to include gender. Yet he had a romantic view of women, despite his belief in what they could accomplish in modern society. Stieglitz said in describing O'Keeffe's art that, "The woman receives the World through her Womb. That is the seat of her deepest feeling."

Because of the beauty of O'Keeffe's art, it has always been referred to as a uniquely feminine expression.

Red Canna,

1924, oil on canvas mounted on masonite; 36 x 29 7/8 in. (91 x 76 cm).

The University of Arizona Museum of Art, Tucson, Arizona.

Louis Kalonyme, an intensely Freudian art critic, once wrote that O'Keeffe's art was ". . . a shamelessly joyous avowal of what it is to be a woman in love . . . " adding that she was "devoid of the feminine cringe and giggle."

While it is true that her ability to harmonize a myriad of vibrant colors inevitably led to objects of great beauty, O'Keeffe was merely trying to capture her own complete accord with nature. Her minute study of detail, her desire to portray something that had never been seen before, something "so simple and so obvious that it is right before one's very eyes," is what transformed her glorious designs of flowers into symbols of life.

Stieglitz welcomed discussion of sex and Freudian motivation behind O'Keeffe's flowers as a way of generating interest in her work. Freudian psychology was at the time a popular method of explaining personality and consciousness. Dr. Freud's ideas were becoming better known in America, after he had delivered a lecture in 1909 at Clark University in Massachusetts. These novel theories were influencing thought in modern fiction and on the science of human sexuality, in addition to the work of artists in the Stieglitz circle.

Stieglitz himself had no qualms about exhibiting his intimate photo series of O'Keeffe's body both in 1921 and after the solo exhibit of her large distinctive flowers in 1923. Marsden Hartley was one of the first to praise O'Keeffe's work in terms of sexual innuendo. Herbert Seligmann also stated of O'Keeffe, "her body acknowledges its kindred shapes." Helen Appleton Read, however, a critic for the *Brooklyn Daily Eagle* (and a former classmate of O'Keeffe's), was repulsed by the images, saying "the shameless naked statements are too veiled to be anything but rather disturbing . . . they seem to be a clear case of Freudian suppressed desires in paint."

O'Keeffe generally thought that the interpretations of critics and fellow artists of her work had little to do with the way she expressed her feelings about objects and life. In later years she would poke sly fun at

Freudian explanations by insisting that her focus on holes in the pelvic bone series sprang from a childhood habit of eating around the hole in a doughnut or a raisin in a cookie, deflecting more sexual interpretations of such paintings.

PATTERNS

O'Keeffe painted the natural world at its most elemental—the corollas, calyxes, petals, and stems. Flowers are the sexual organs of plants and their forms reflect reproductive patterns established deep in biological history, the necessary mechanisms for the coming together of two individuals to create a new organism.

Black Iris III (1926) is one of the paintings most frequently referred to as an example of the artist's use of sexual imagery. O'Keeffe's remembrance of the iris series is far more prosaic—she could only get irises for two weeks in the year, from specific florists. She would stay in the house for days while a blossom opened, determined to capture its essence.

As the social philosopher Lewis Mumford stated in the March 2, 1927, issue of *The New Republic*, just before O'Keeffe's first retrospective exhibition by the Brooklyn Museum: ". . . The point is that all these paintings come from a central stem; and it is because the stem is so well grounded in the earth and the plant itself so lusty, that it keeps on producing new shoots and efflorescence, now through the medium of apples, pears, egg plants, now through leaves and stalks, now in high buildings and skyscrapers . . ."

The Calla Lily paintings were begun in 1923, and were smaller than O'Keeffe's later flower paintings. She was first drawn to paint the calla lily after seeing

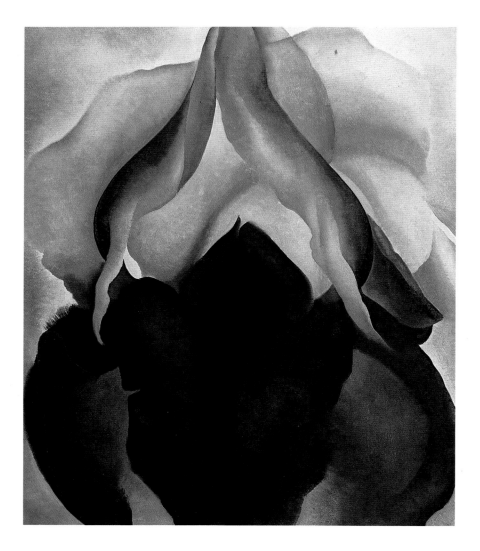

Black Iris III

1926, oil on canvas; 36 x 29 7/8 in. (91 x 76 cm). The Alfred Stieglitz Collection, The Metropolitan Museum of Art, New York.

In the catalog statement for her exhibition in 1939, O'Keeffe wrote that she magnified her flowers because ". . . nobody sees a flower—really—it is so small—we haven't time." She decided that if her flowers were large enough even busy New Yorkers would have to take time to see what she saw in the blossoms.

Two Calla Lilies on Pink

1928, oil on canvas; 40 x 30 in. (102 x 76 cm). Bequest of Georgia O'Keeffe for the Alfred Stieglitz Collection, The Philadelphia Museum of Art, Philadelphia, Pennsylvania.

In the midst of the fevered commentary on the symbolism of O'Keeffe's flowers, Stieglitz referred to her calla lily paintings as "the Immaculate Conception." Mexican artist Miguel Covarrubias even drew a caricature of O'Keeffe as "Our Lady of the Lily."

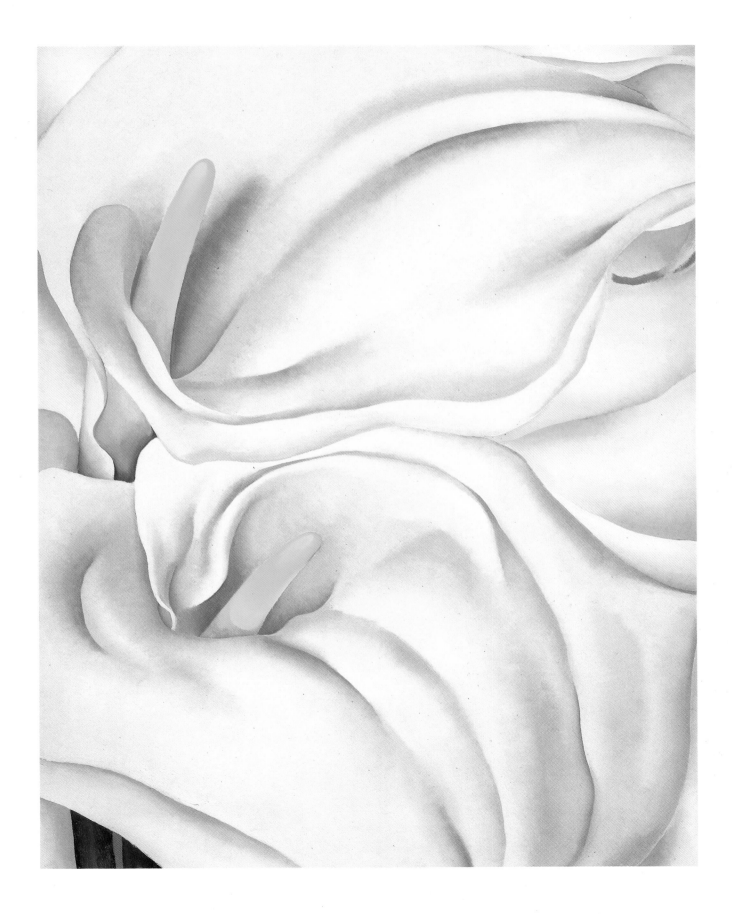

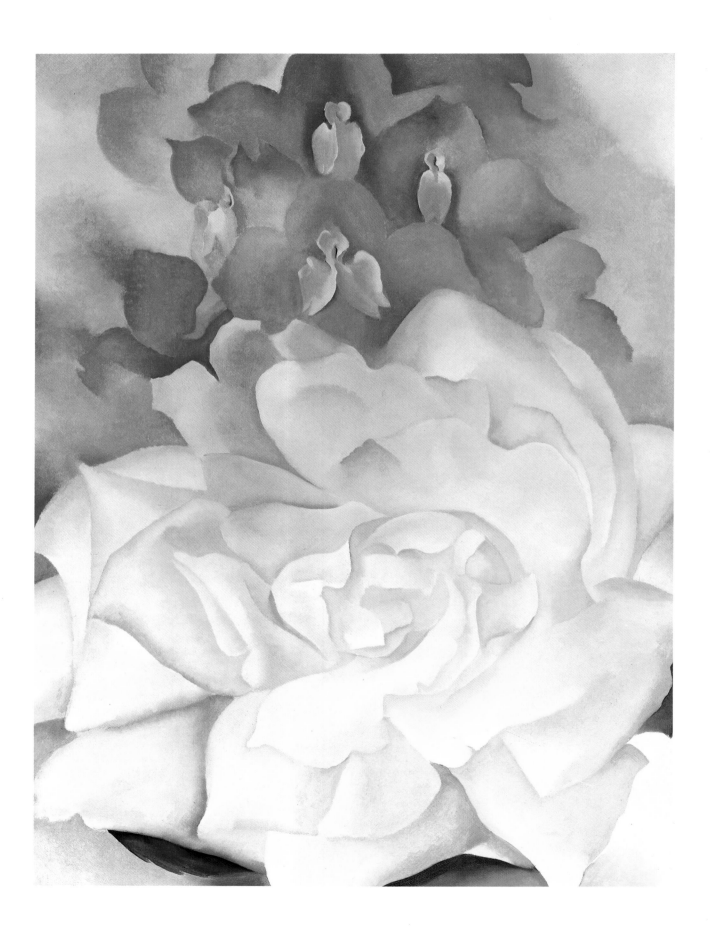

paintings done by her friend Marsden Hartley. Hartley's work was also being discussed in terms of eroticism, but O'Keeffe decided to try a calla "to see if I could understand what it was all about."

The early callas, such as *Calla Lily in a Tall Glass, No. 1* (1923), are vertical compositions. They are usually single blooms in elongated vases against a monochromatic background, creating a remarkably spare and elegant design. O'Keeffe admired the waxy texture of the petal, its sharp edge containing the gently swelling concavity. The prominent stamen was sometimes described in masculine symbols, while the smooth roundness of the bell-shaped petal evoked feminine associations.

Incorporating the rhythmic waving lines of earlier abstractions and employing them as part of decorative abstract patterns within flowers was a natural step in the progression of O'Keeffe's art. She also utilized well the familiar undulating waves of finely graduated hues, which helped create the organic brilliance of her flowers.

DETAILS

O'Keeffe's love of painting flowers started early, back when she was taking art lessons in high school. She remembered her art teacher holding up a jack-in-the-pulpit, pointing out the strange shapes of the petals and color gradations, from deep purple to the green of its leaves. Though O'Keeffe had seen jack-in-the-pulpits before, she had been struck by the teacher's close examination of the flower—pulling back the hood to reveal the "jack" inside and turning it slowly

White Rose with Larkspur, No. 2

1927, oil on canvas; 40 x 30 in. (101.6 x 76.2 cm). Henry and Zoe Oliver Sherman Fund, Museum of Fine Arts, Boston, Massachusetts.
"I know I cannot paint a flower . . ." O'Keeffe wrote to William Milliken in 1937, "but maybe in terms of paint color I can convey to you my experience of the flower."

before the students. This may have been the most lasting lesson O'Keeffe learned—the need to see an object with such detail in order to be able to draw it.

In the 1920s a general reverence for detail was influencing the arts and education in America. John Dewey, an educational reformer, proposed that American teachers emphasize the details of the real world as a basis to explore general concepts, theories, and ideas. It was believed that through the particulars, one could understand the whole. Yet when O'Keeffe moved from the modest profiled portraits of the calla to a deeper explorations of the designs within the flower, critics went wild with the possiblity of symbolic meanings rather than seeing this simply as a deeper exploration of the subject.

O'Keeffe always denied that there was any symbolism, sexual or otherwise, in her flower paintings. Her art was based entirely on aesthetic considerations of her environment. While she lived on 59th Street, the artist would take long walks up and down the surrounding blocks. On the ground floors of many buildings in her neighborhood there were small markets with banks of exotic blooms in front. O'Keeffe was accustomed to only seeing cut flowers in season, and these rare blooms of remarkable size were a marvel of color and form, and a true inspiration to her.

O'Keeffe usually kept flowers in her room, supplying for herself that necessary bit of nature she missed in the city. Flowers were treasured objects, and as she valued them more, she looked at them more closely. As she herself said, "I rarely paint anything I don't know very well."

What interested O'Keeffe was not just the flower itself but, more specifically, the colors and shapes within the flower. As she said, "You paint *from* your subject, not what you see." This can be seen in *White Rose with Larkspur, No. 2* (1927), which is a spiral into the heart of the flower, with shadows evoked as if they were petals themselves, substantial in their ability to merge the individual petals into a swirling, living

entity. The very heart, as always, is softened, as if to emphasize the difficulty in truly, wholly seeing into the depths of a single flower.

With some of O'Keeffe's later oils, a sharper, more realistic line appeared, emphasizing the formal concerns of color and design. This formal boldness of line can be seen even in late flower paintings, such as *White Trumpet Flower* (1932).

Her desire to capture the true detail of her objects gave her work a very realistic aspect—some of her flower studies, for their precision, could be taken as horticultural illustrations. Yet her exploration of details in such depth ultimately turned her studies into abstracted patterns of perfection.

This basic abstract sensibility can also be observed in the repetition of specific flowers in her series. With the petunia, for example, the artist progressively simplified and stylized it to the point where the original subject becomes almost unrecognizable—still, the painting breathes with life and the fragrance of a real bloom. In later works, O'Keeffe would eventually transform a pelvic bone into a beautifully abstract pattern of hollows and curves.

MAGNIFICATION

O'Keeffe's enlarged flowers were like nothing else in American art in that time. Flowers were usually painted small and delicately rendered to recreate a sense of their fragility and relationship to man. When the flowers are viewed close-up, however, there is a conscious immediacy. We would normally see a flower in this intensity only when it is near our face, and the reproduction of that intimacy on such a monumental scale is startling to the senses.

Some critics were uncomfortable with the lack of arm's-length perspective in O'Keeffe's paintings,

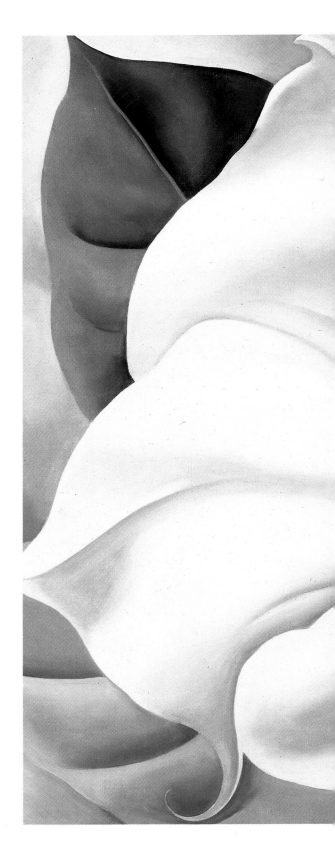

White Trumpet Flower

1932, oil on canvas; 29 3/4 x 39 3/4 in. (76 x 101 cm).

Gift of Inez Grant Parker in Memory of Earle W. Grant,

The San Diego Museum of Art, San Diego, California.

In 1937 O'Keeffe discussed her method of painting flowers with her friend Anita Pollitzer, saying, "At the time it seemed to me as though the flower I was painting was the only thing in the world. I didn't think of it as small."

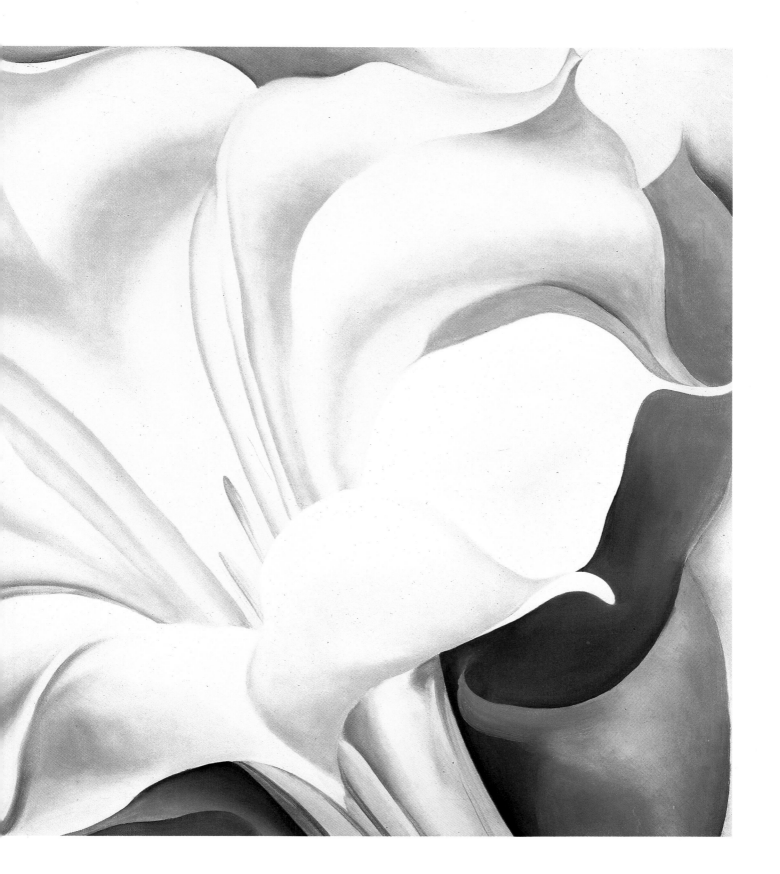

equating the intimacy of the view with intimacy of the body. Others marveled that the enlargements did not destroy the feeling of a flower but rather magnified its inherent beauty.

O'Keeffe once claimed that the size of her flowers was inspired by the skyscrapers being built all over New York. Perhaps she saw the world expanding a few notches on the physical scale, with nothing too monumental to grasp. Or perhaps, also, she felt dwarfed by towering skyscrapers, and retreated for safety into the focused heart of a blossom. The flowers loomed large in her private, paint-filled world, and she rendered them that way.

Other critics have traced the scale of these pictures to the influence of photographic enlargements, such as those that Stieglitz was working on during the 1920s. The camera certainly had a new and unique ability to focus closely on details, revealing surprisingly abstract patterns. His cloud photos disclosed that a fragment of the whole could be more truly evocative of the subject.

Fragmentation inevitably led to isolation, reflecting O'Keeffe's new tendency to place her still lifes in a void. In *Petunia* (1925) she separated the flower from its natural environment, rendering it against an undulating white backdrop. By liberating the flower from its place in landscape, the painter was able to concentrate on the unique patterns within, allowing the viewer to do so as well.

O'Keeffe painted many studies of poppies. The flower was common in the oriental works that contemporary artists were exploring at that time. O'Keeffe was pleased to learn that she was the first to experiment with enlarged flower details since Chinese artists of nearly a hundred years earlier did so. Just as she clustered leaves together, she gathered blooms alike to create mirror repetitions of the most fundamental patterns of line and color.

COLOR

O'Keeffe's sense of color differed from that of other artists who were painting in America between the world wars. The realists tended to prefer a monochrome palette, perhaps still influenced by the cubist sensibility, wherein form and line were the purest aesthetic reflection of an object.

In a 1923 review, *New York Sun* critic Alan Burroughs wrote: "Flowers and fruits burn in her conception of them with deep, luminous colors that have no names in spoken or written language." In a *New York Times* review of Stieglitz's show "Seven Americans" the reviewer also praised O'Keeffe's flowers, saying ". . . how beautifully they grow." This living tension is partly created by O'Keeffe's use of light among her colors. She enjoyed emphasizing the difference between the sharp, contrasting line at the edge of the petal and the curving effervescence of the petal itself.

O'Keeffe's study of color can be traced through her Canna Flower series. *Red Canna*, a watercolor done in 1919, is an enlarged detail of a cross section of a canna flower, flattened into the abstract essence of its form. The surging lines radiate in a burst pattern that is similar to the painter's abstract forms, but there is a new fluidity to her colors here that helps create a lively, resonating feeling. In this watercolor, O'Keeffe focused on the decorative pattern of colors deep in the recesses of the flower. Two years later, in *Canna— Red and Orange*, she captured the bold clash of red and yellow, with gradations of orange radiating from the gold spiraling heart of the blossom.

As O'Keeffe wrote to William Milliken, she was not sure whether the flower or the color was her primary focus, adding ". . . I do know that the flower is painted large to convey to you my experience of the flower—and what is my experience of the flower if it is not color?"

Red Canna

c. 1919, watercolor on paper; 19 3/8 x 13 in. (49 x 33 cm).
Gift of George Hopper Fitch, B.A. 1932 and Mrs. Fitch,
Yale University Art Gallery, New Haven, Connecticut.
O'Keeffe's fellow artists Marsden Hartley and Charles Demuth inspired her to begin painting flowers, but her renderings generated far more Freudian commentary than their own. Whether this was simply because she was a woman or was due to her startling methods of enlargement is difficult to determine.

Flower Abstraction

*1924, oil on canvas; 48 x 30 in. (122 x 76 cm). 50th Anniversary Gift
of Sandra Payson, The Whitney Museum of American Art, New York.*
In this vertical motif the center of the flower seems to
merge with the cloudy sky, taking the viewer into the flower
and beyond. O'Keeffe ushers us into the misty, innermost
heart of the blossom to discover the vibrating white light
of life flowing like a river from the heart of the image.

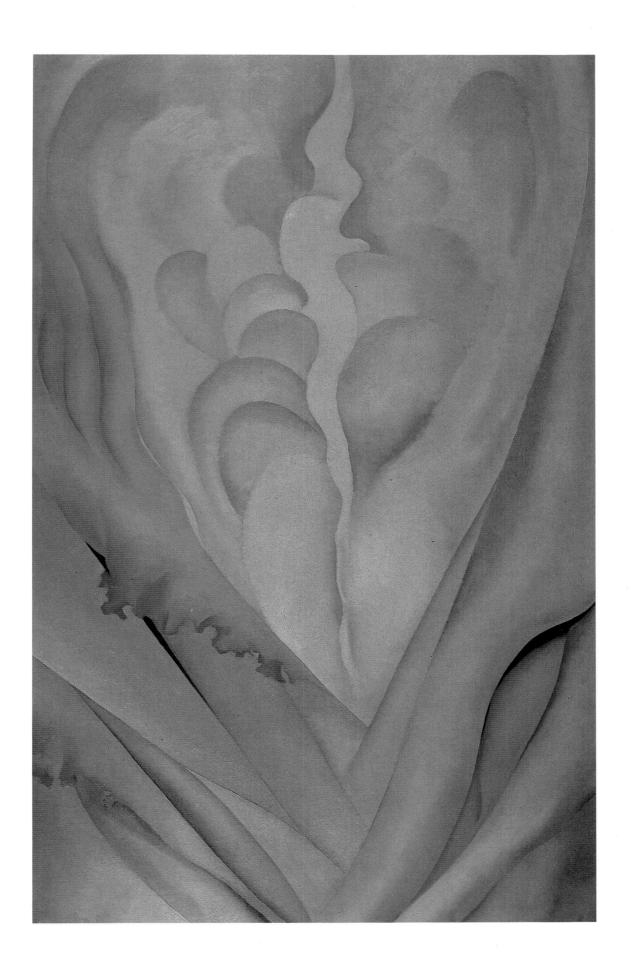

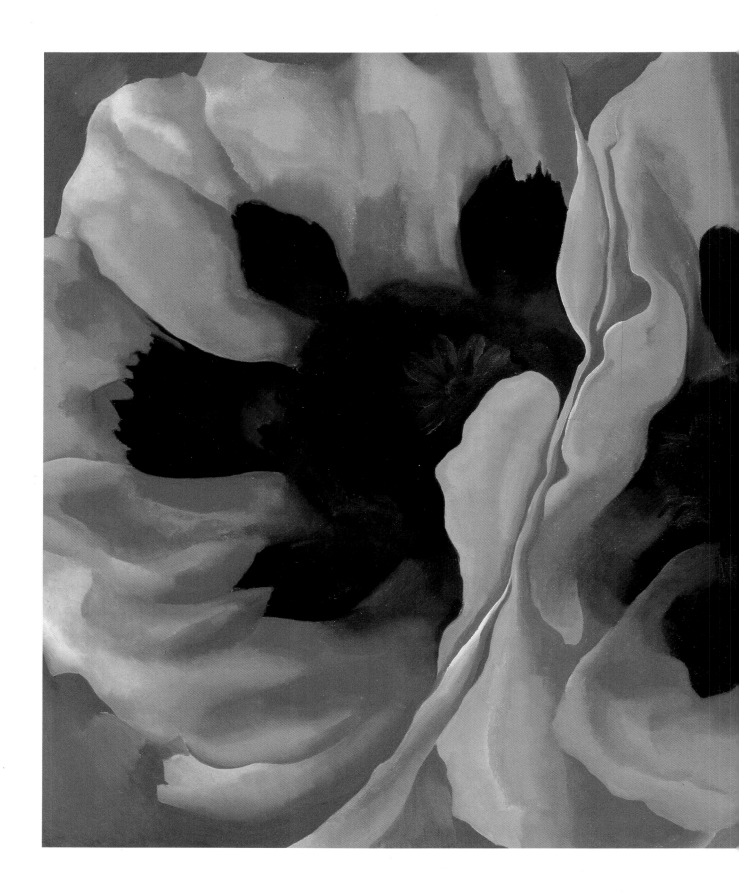

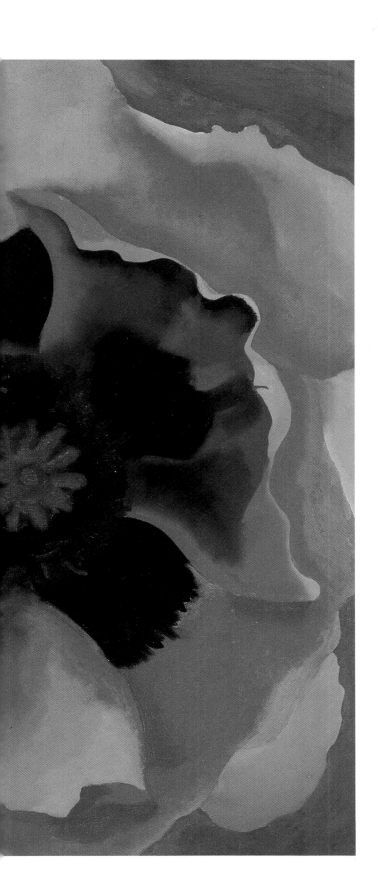

Oriental Poppies,

1928, oil on canvas; 30 x 40 1/8 in. (76 x 102 cm).
Collection, University Art Museum, the University
of Minnesota, Minneapolis, Minnesota.
While working on her paintings, O'Keeffe
would often turn them to make sure the composi-
tion was balanced from every direction. This
particular work was exhibited for a long time with
the poppies appearing on top of one another
rather than in its proper horizontal orientation.

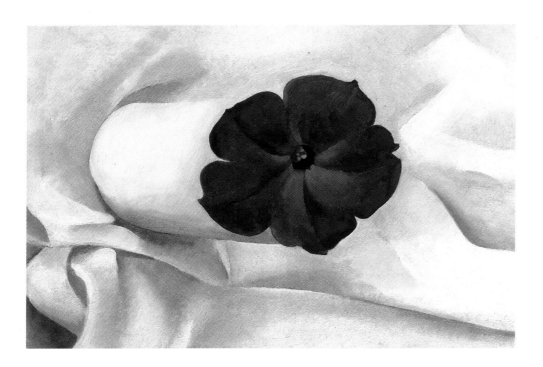

Petunia

1925, oil on board; 10 x 7 in. (25.4 x 17.8 cm).
Bequest of Elise S. Haas, San Francisco Museum
of Modern Art, San Francisco, California.
This composition looks directly into the heart
of the intensely rich blossom. The magenta
hues are velvety in their richness, shading quite
naturally into deep purple and violet shadows.

Morning-Glory with Black

1926, oil on canvas; 36 x 30 in. (91.4 x 76.2 cm). Bequest of Leonard
C. Hanna, Jr., The Cleveland Museum of Art, Cleveland, Ohio.
O'Keeffe wrote in "About Myself," her catalog state-
ment of 1939: "Everyone has many associations with
a flower—the idea of flowers. You put out your hand
to touch the flower—lean forward to smell it . . ."

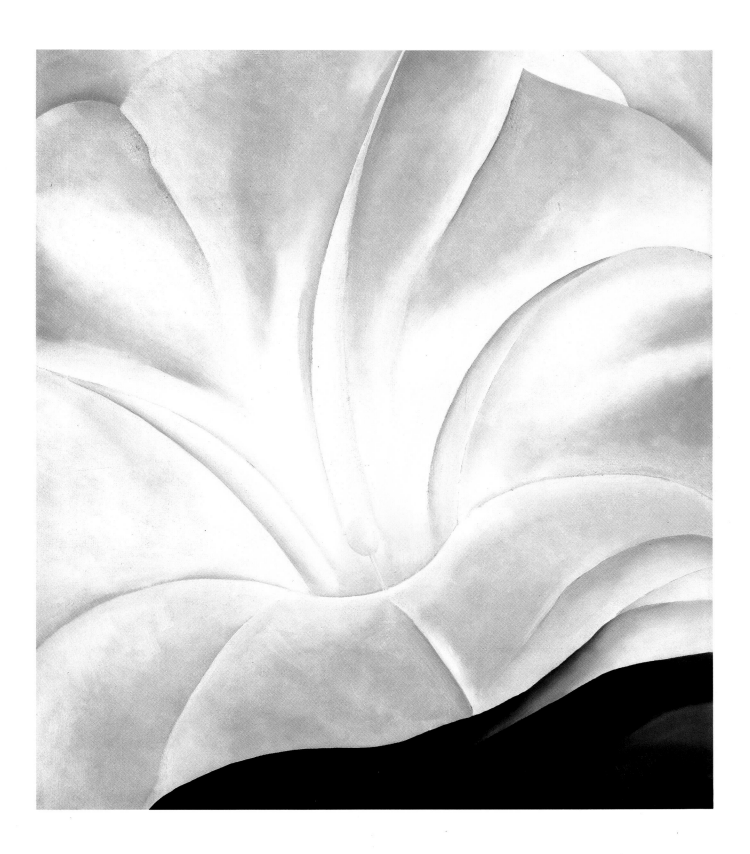

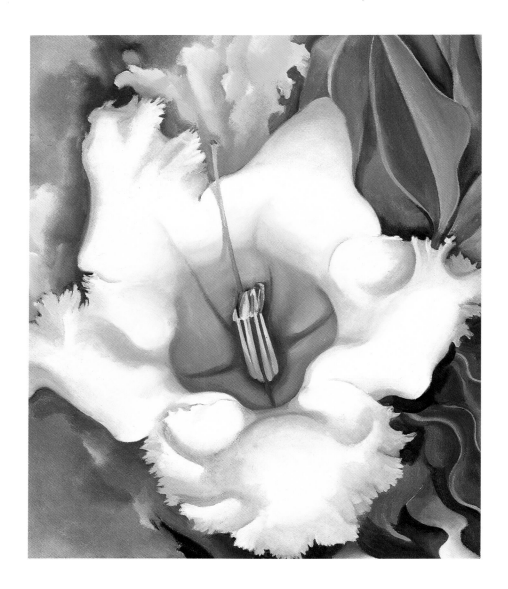

Cup of Silver

1939, oil on canvas; 19 3/16 x 16 1/8 in. (48.7 x 41 cm). Gift of Cary Ross,
BMA 1940.122, The Baltimore Museum of Art, Baltimore, Maryland.
O'Keeffe was relieved when one influential critic,
Henry McBride, praised the artist's "touch and
clarity of color," adding that "to overload them with
Freudian implication is not particularly necessary."

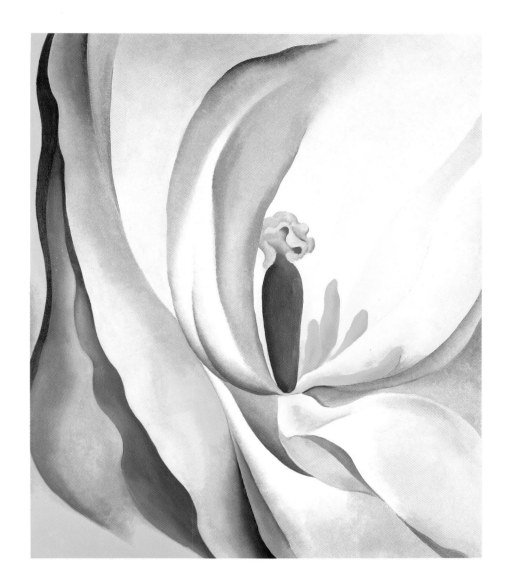

Pink Tulip

1926, oil on canvas; 36 x 30 in. (91.4 x 76.2 cm); Bequest of Mabel

Garrison Siemonn, in Memory of her Husband, George Siemonn,

BMA 1964.11.13, The Baltimore Museum of Art, Baltimore, Maryland.

O'Keeffe painted her flowers so that viewers could look at something familiar

in a new way. She surely was not expecting critics such as Helen Appleton Read

to write that "they seem a clear case of Freudian suppressed desires in paint."

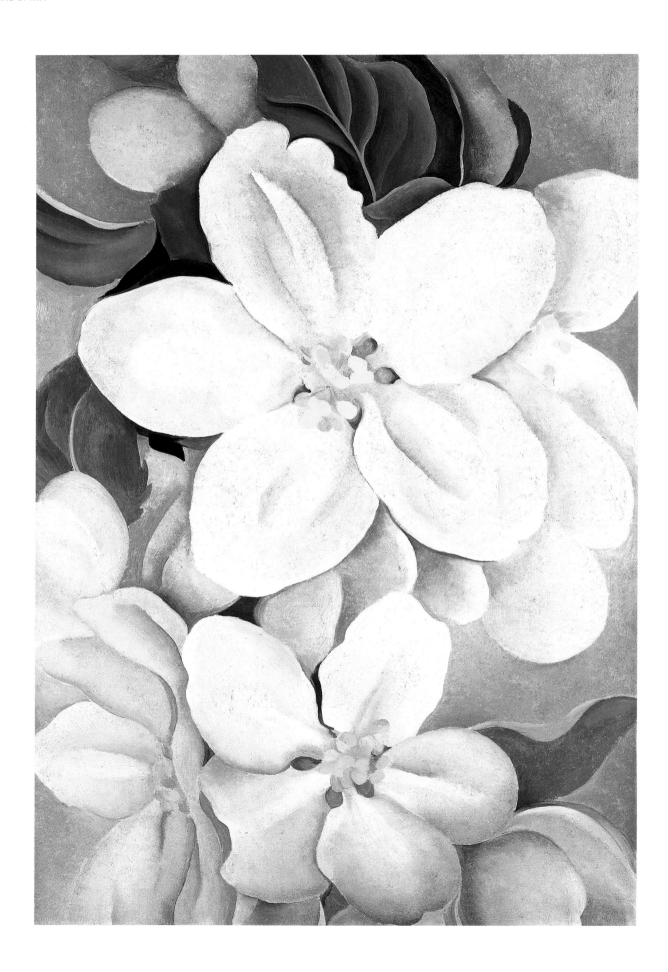

Apple Blossoms

1930, oil on canvas; 37 x 26 in. (94 x 66 cm). Gift of Mrs. Louis Sosland, The Nelson-Atkins Museum of Art, Kansas City, Missouri.
O'Keeffe considered color to be one of the things that makes life worth living. She thought of her painting as a way to create an "equivalent with paint—color for the world—life as I see it."

Black Hollyhock, Blue Larkspur

1929, oil on canvas, 36 x 30 in. (91.4 x 76.2 cm). George A.
Hearn Fund, 1934, The Metropolitan Museum of Art, New York.
The lush, velvet petals of the black hollyhock enclose a
center of light burning like a sun. The intensity of O'Keeffe's
colors was extreme, and offended those who were accustomed
to viewing artwork with a more conventionally subdued palette.

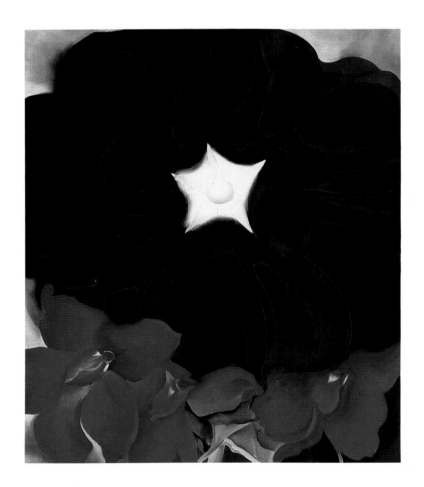

Yellow Hickory Leaves with Daisy

*1928; oil on canvas; 29 7/8 x 39 7/8 in. (76 x 101.3 cm). Gift of Georgia O'Keeffe
to the Alfred Stieglitz Collection, The Art Institute of Chicago, Chicago, Illinois.*
Flowers, as well as bones, became for O'Keeffe almost an alphabet
for expressing her special way of looking at the universe.

Cow's Skull with Calico Roses

1931, oil on canvas, 35 7/8 x 24 in. (91.2 x 61 cm). Gift of
Georgia O'Keeffe, The Art Institute of Chicago, Chicago, Illinois.
In the hollows of the bones O'Keeffe painted were
openings to a new dimension where light and color ruled
in an increased intensity. She did not look upon bones
as symbols of death, but rather of longevity and survival.

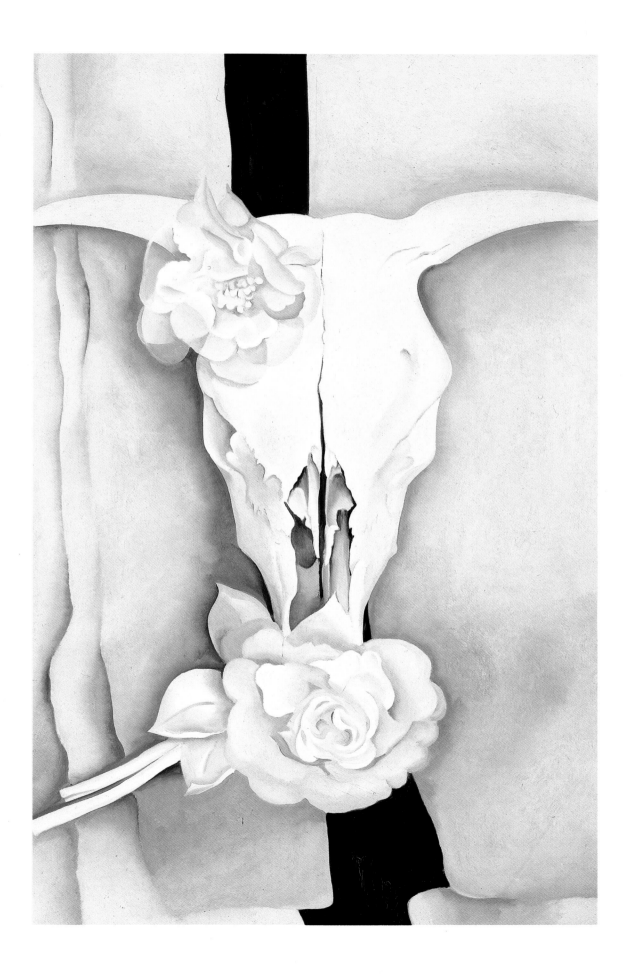

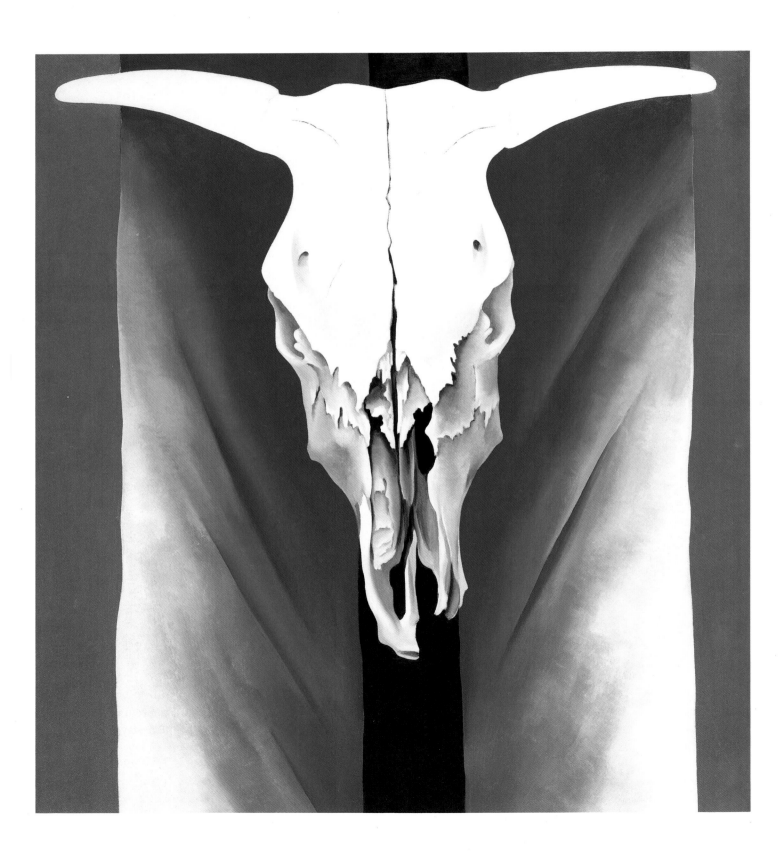

CHAPTER THREE

THE SOUTHWEST YEARS

O'Keeffe's first experience of the southwest came when she taught art in public school in Amarillo, Texas, from 1912 to 1914. At that time, Amarillo was still a frontier town, the site of a brisk trade in buffalo and cattle byproducts. A large stockyard was situated in the middle of the town, and the wide avenues had large frame houses and trees that were all under four feet (1.22 meters) tall. One road led out of town, stretching to the horizon. To the twenty-five-year-old O'Keeffe, the southwest was a place of freedom and excitement. She also thought the desolate landscape was beautiful, saying, "To see and hear such wind was good." Georgia's sister Catherine once said that the wide-open Texas countryside seemed to give O'Keeffe the freedom to draw just for herself, ". . . work that was like that of no one else."

During her years teaching in Amarillo, O'Keeffe wrangled with the school board over the curriculum of the art classes. She refused to accept the Prang drawing book that the school district had ordered for her classes. Instead, she used the Dow Method, which she had learned the previous summer under Alon Bement at the University of Virginia. And to everyone's consternation, she encouraged her students to bring in objects from the local surroundings. She felt that things that were familiar to the children would

make it easier for them to see the natural lines and colors in the subjects, while the traditional copybook patterns were stereotyped, interfering with true self-expression.

Then in 1916, with her youngest sister, Claudia, O'Keeffe vacationed in Colorado, near the Rocky Mountain National Park. En route their train was detoured through New Mexico, and O'Keeffe stayed a couple of days in Santa Fe. As she later said: "I loved it immediately. From then on I was always on my way back."

By 1928 O'Keeffe was prospering financially from the sale of her work. She wanted to build her own house at Lake George, but Stieglitz enjoyed being surrounded by his family and friends. As the eldest son, he was now the patriarchal head, which resulted in O'Keeffe inheriting heavy responsibilities in running their family house. She longed for a place of her own where she could ". . . get off sometimes, and put my rocks and precious things where I wish."

She began to feel stifled even in the natural surroundings of Lake George. A series of debilitating illnesses, beginning with an operation for a benign tumor in 1927, and a long struggle for both Stieglitz and O'Keeffe during the winter of 1929, marked the end of an era. The doctor recommended a change of scenery for O'Keeffe, and this prompted her first trip west in a decade. She was accompanied by Rebecca Strand, the wife of Paul Strand, a photographer among Stieglitz's artists. The two women stayed at the home of arts patron Mabel Dodge Luhan, who had given writer D. H. Lawrence and his wife Frieda a ranch north of Taos on the side of Mount Lobo in exchange for the autographed manuscript of *Sons and Lovers*.

Cow's Skull—Red, White and Blue

1931, oil on canvas; 39 7/8 x 35 7/8 in. (101 x 91 cm). The Alfred Stieglitz Collection, 1952, The Metropolitan Museum of Art, New York.
O'Keeffe wrote that the inspiration for this particular painting were the cattle in Amarillo, Texas. She considered the scene to be important and uniquely American, deciding ". . . just for fun I will make it red, white and blue, a new kind of flag almost."

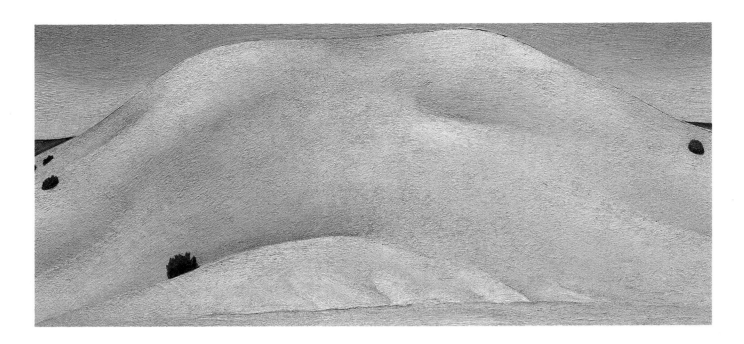

Soft Gray, Alcalde Hill (Near Alcalde, New Mexico)

1929–1930, oil on canvas; 10 1/8 x 24 1/8 in. (26 x 61 cm). Gift of Joseph H. Hirshhorn, 1972, Hirshhorn Museum and Sculpture Garden, Smithsonian Institution, Washington, D.C. Painted during her first trip to New Mexico, this work is the artist's response to the magnificence of the countryside, emphasizing the size of the low, symmetrical hill. O'Keeffe was much more interested in capturing the texture of the swells than in rendering an exact reproduction.

During O'Keeffe's trip to the southwest in 1929 she visited Abiquiu, New Mexico, in the Chama River Valley, where the river flows into the Rio Grande. There, a handful of small houses stood on the foothills beneath a long black mesa. It had been a settlement in the west for generations, as can be attested to by the nearby Pueblo Indian ruins. In the 1920s the area was populated by descendants of both the Indians and Spanish settlers.

O'Keeffe admired the strength it took to live in the desert and preferred this isolation to Taos, where the artists usually gathered to play and work. The blinding sunlight of the American west posed problems for some artists, but O'Keeffe gloried in the intensity, noting that all the colors of the spectrum were possible in this intense white light. She also enjoyed the sweeping views, the spare majesty of the untouched earth, and the beauty of the mountains and mesas. The artist found that the patterns changed with the sunlight, creating new images with every hour and season.

While O'Keeffe stayed in New Mexico for a few months, Stieglitz spoke of his suffering to everyone who came to his gallery. He felt he had lured O'Keeffe away from her beloved west ten years ago by offering to support her, and now he was afraid he was losing her to her first great love.

When she returned to New York, O'Keeffe was relieved when critics began reviewing her New Mexico paintings more in terms of their aesthetic properties—including her compositional tendency to isolate or "float" her subjects. This was seen as part of an increasing surrealist tendency in her art, ignoring the fact that she had been isolating subjects since 1918, in her very first apple still lifes. The surrealist artists emphasized the irrationality of reality, while O'Keeffe was searching for basic patterns that implied the underlying unity of existence.

BONES

During her second summer in the New Mexico desert O'Keeffe began to notice the bones baked white by the intense sun. The same regard for colored texture that gave her flowers such vibrant life was applied to the weathered bones that had been polished to a gleam by wind-blown sand.

In an effort to bring the desert back to the city with her, O'Keeffe even began to pack barrels full of

bones to send to New York. She spoke of them as her trea-sures, and created many of her bone paintings during the winter months in New York.

When presented with her new bone paintings, the art world reacted by shifting from overtly sexual interpretations to ruminations over O'Keeffe's "obsession" with objects of death. Some critics even attempted to equate the bones with O'Keeffe's childlessness, despite the fact that other painters, such as Alexander Hogue, Jerry Bywater, and Otis Dozier, were also focusing on bones in their Dust Bowl paintings from the 1930s.

O'Keeffe loved the subtle gradations of white in the bones, so pure it captured and reflected light-saturated color at every angle. At first she painted skulls, ribs, jawbones, and thigh bones, then later she turned to horns and vertebrae. As she progressed, and true to her reductivist spirit, she moved from an examination of the head to the simpler form of the pelvis.

In 1943 she began a ground-breaking series of paintings inspired by the pelvis bones of animals. She found the pelvis to be ripe with natural curves and planes, and studied the bones in a method similar to that of her series of flower magnifications. At first she "floated" the bones in infinite skies. These bones were inherently less recognizable than skulls or horns, and they lent themselves more readily to the painter's abstractionist explo-rations.

Eventually, she focused upon the central hole in the depths of the hip joint, emphasizing with color the infinity of the sky. During the height of World War II, O'Keeffe said she believed the hole hinted at the void that would remain "after all man's destruc-tion is finished." One can easily understand her placement of hope in nature rather than in man himself during that troubled time.

Pelvis with Moon

1943, oil on canvas; 30 x 24 in. (76 x 61 cm). The Collection of the Norton Gallery of Art, West Palm Beach, Florida.
O'Keeffe became most intrigued by the holes in bones—and what she saw through them—particularly the color blue as she held them up against the sky. The artist believed these holes to be considerably expressive.

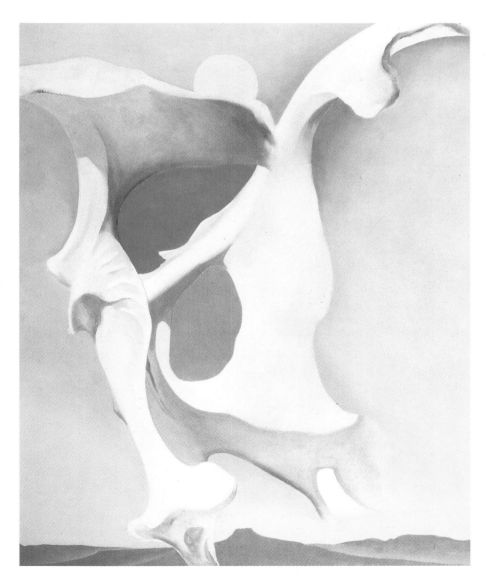

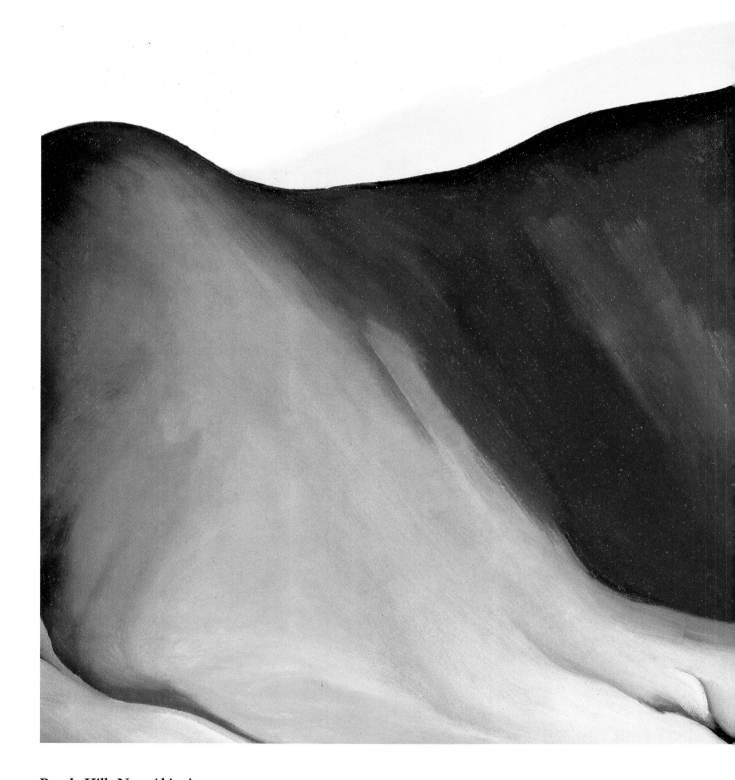

Purple Hills Near Abiquiu

1935, oil on canvas; 16 x 30 in. (40.6 x 72. 2 cm). Gift of Mr. and Mrs.
Norton S. Walbridge, The San Diego Museum of Art, San Diego, California.
O'Keeffe would walk in the evening ". . . up in the
desert where you can see the world all around—far away."

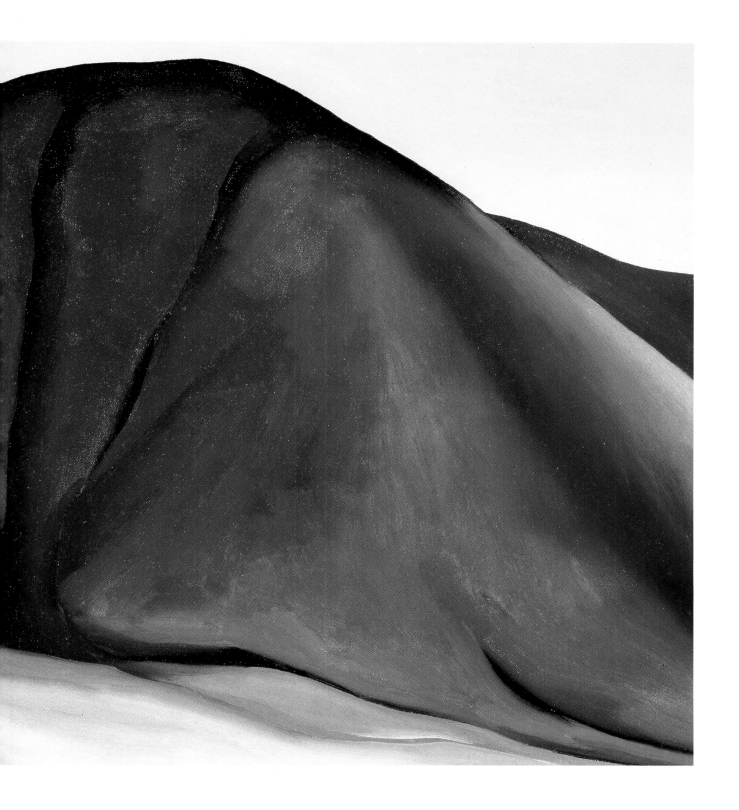

LANDSCAPE

In 1931 the Museum of Modern Art invited O'Keeffe and sixty-four other artists to submit a drawing for a prospective mural for the interior of Radio City Music Hall. O'Keeffe's drawing was entitled *Manhattan* and it depicted a dreamy cityscape, with a pair of camellias floating over its skyscrapers. Her design won first prize and was chosen to decorate the second floor women's room.

While waiting for the contractors to complete their part of the work, O'Keeffe was unable to go west. She went instead to Lake George with Stieglitz, and it did not help matters that her husband (who also acted as her business manager) was incensed with the whole project. Her canvases at the time were fetching from four to six thousand dollars, and the fee for the large mural was only $1,500. Once O'Keeffe was finally able to start the mural, there were problems with the fixative for the canvas, and she had to stop work on it. Soon after that she suffered a nervous breakdown, and had to stop painting altogether. In 1933 she was hospitalized in New York for psychoneurosis.

Upon her recovery, after being away for three years, she finally returned to her beloved New Mexico. In 1934 O'Keeffe explored the region north of Abiquiu, and when she reached Ghost Ranch, New Mexico, she had found a place she would return to time and

Ghost Ranch

MYRON WOOD, 1979–1981; photograph. Myron Wood Photographic Collection, The Pikes Peak Library District, Colorado Springs.
This was O'Keeffe's first house in New Mexico. She painted the cliffs in the background from the roof of the building.

again. She immediately rented a one-room "cottage" lit by kerosene lamps, ate at the lodge, and spent all day outdoors.

In the starkness of the desert O'Keeffe concentrated on the fundamental rhythms of the earth. The lines of the mountains against the sky, the blending of air and earth by reflected light and color inspired her, and she wrote ". . . All the earth colors of the painter's palette are out there in the many miles of bad lands . . . our most beautiful country. . ."

O'Keeffe began to play more extensively with the depth of view in her compositions. By contrasting an intense foreground object against infinite horizons, she seems to capture every state of existence in between. At first she usually painted her subjects with a loose brushstroke, moving to greater refinement and restraint as she honed in on certain details, exploring in her subjects the convex forms and the concavities which could evoke the whole.

The bony ridges of the hills echo the same spare essentials that fascinated O'Keeffe in her Bone series. She also painted trees in the same starkly elegant manner, stripping them of all but the most essential detail. In particular, O'Keeffe was drawn to the knurled trunks of dead trees, with their branches curving in silver gray fingers toward the harsh sun.

In the summer of 1940, clearly retreating ever further into the isolation of the desert, O'Keeffe settled in Ghost Ranch, near Canjilon Creek, sixty-five miles (105 kilometers) from Santa Fe, and sixteen miles (25 kilometers) from Abiquiu. Her small adobe house faced an imposing, flat-topped mountain called the Pedernal. She painted this view many times over the decades, as well as that of the circle of pink, red, and yellow cliffs behind the house.

That summer, O'Keeffe also became embroiled in the illegitimate birth of her servant's baby. She arranged for the girl to be married to the father of the baby, and spent most of the summer helping to take care of the child. O'Keeffe had always wanted to have a child, and had spoken of it often to friends in the early 1920s. But Stieglitz had refused to consider starting a family, even before they were married.

The strain of the yearly separations was telling on the couple, and obviously affected the latter years of their marriage. It has also been conjectured that Stieglitz's interest in the young, married sponsor of An American Place, Dorothy Norman, contributed to

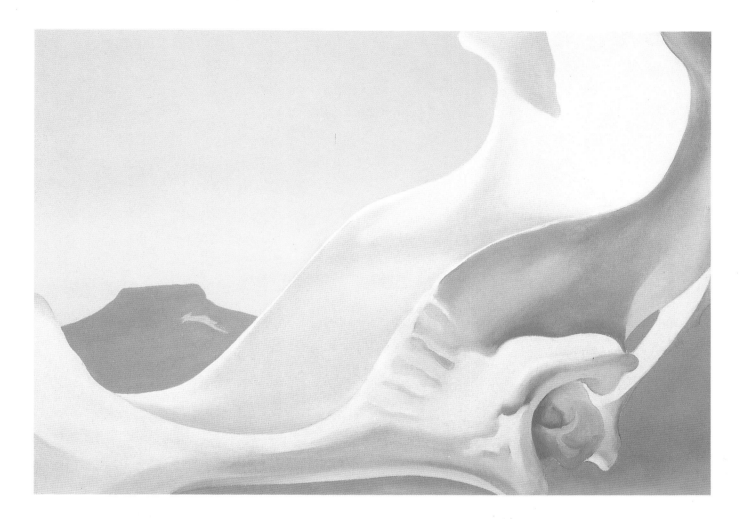

Pelvis with Pedernal

1943, oil on canvas; 16 x 22 in. (41 x 56 cm). Munson-
Williams-Proctor Institute, Museum of Art, Utica, New York.
O'Keeffe referred to the bones she collected as striking
to the ". . . center of something that is keenly alive
on the desert even though it is vast and empty and
untouchable—and knows no kindness with all its beauty."

O'Keeffe's breakdown in the early thirties. Aside from financing Stieglitz's gallery early in the 1930s, Norman was herself a photographer, and had allowed Stieglitz to use her as a model just as he had earlier utilized O'Keeffe.

Throughout the 1930s and 1940s, Stieglitz refused to travel to the southwest. He was busy running his gallery, and would spend only his summers in his beloved Lake George. O'Keeffe would travel up to Lake George in early spring to ready the house for Stieglitz, and she would return to the lake in the fall, before Stieglitz returned to the city. She asked him many times to come "just to see," but as the years passed Stieglitz used the excuse of his bad heart—which he believed would not be suited to the Abiquiu altitude of 6,000 feet (1,830 meters) above sea level—to avoid the trip.

Other Stieglitz artists, however, such as Paul and Rebecca Strand, Paul Rosenfeld and John Marin,

traveled to New Mexico. Marsden Hartley visited as early as 1918, and wrote of the experience in revelatory terms. His vividly rendered landscapes with swirling, modulated color look like cousins to O'Keeffe's paintings of the desert.

Anita Pollitzer later described the beauty of Ghost Ranch during her visit to O'Keeffe's house in New Mexico in 1945. She was enthralled by the red and black earth, the skies, and the distance from human habitation. After driving through dense junipers and

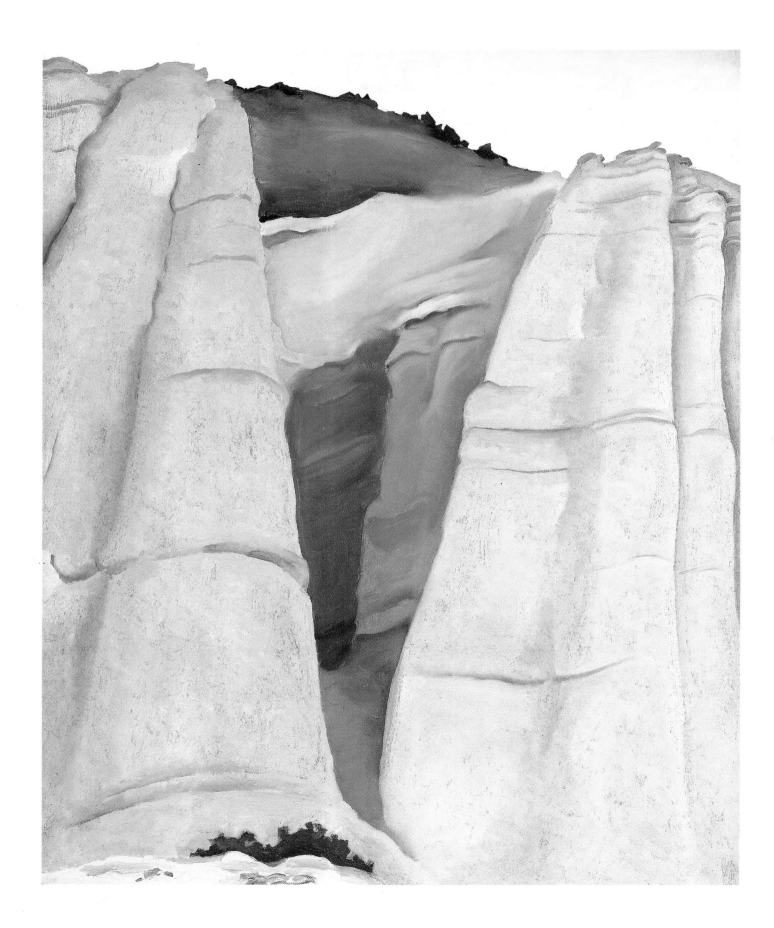

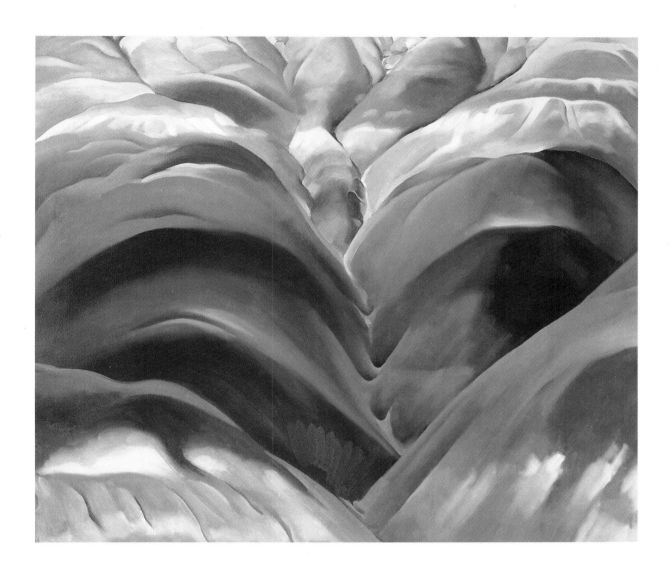

Black Place No. 1

1944, oil on canvas; 26 x 30 1/8 in. (66 x 76 cm). Gift of Charlotte Mack,
San Francisco Museum of Modern Art, San Francisco, California.

O'Keeffe found this site about 150 miles (242 kilometers) north-
west of Ghost Ranch, New Mexico, on the Jicarilla Apache Indian
reservation. Her early depictions are straightforward renderings
of the low gray hills, as can be seen in her *Grey Hill Forms*, which
capture the "elephantine" feeling that she associated with them.

The White Place in Shadow
(From the White Place)

1940, oil on canvas; 30 x 24 in. (76 x 61 cm).
The Phillips Collection, Washington, D.C.

The sedimentary rock across the Chama
River from O'Keeffe's adobe house in Abiquiu,
New Mexico, was unusually light for the
region. The painter frequently renamed her
favorite areas and as soon as she found this
particular site, she called it the White Place.

pinons, she came upon an adobe house, "hidden, until we were actually at its door." She also remembers the sounds of coyotes and the "crashing of an antelope through the nearby brush."

O'Keeffe's big studio window looked out on the Pedernal. Jimsonweed grew wild all around the house, and on one moonlit night O'Keeffe counted over one hundred blooms. She loved to climb the ladder to the roof at night to view the brilliant patterns of the stars.

Sky-watching was always a favorite activity for O'Keeffe. She enjoyed the lightning storms of the west, and sought out splendid vistas in the area. The event of each day was a drive to watch the sunset from some high place, or waking early to catch the sunrise over the Chama River Valley. O'Keeffe often found favorite vistas and renamed them for herself, such as "the White Place" and "the Black Place," a section of black lava deposits left in rows of hills, the debris from a nearby volcanic eruption. Century plants bloomed in the desert, as well as wild purple asters and golden yellow daisies. Her absorption in the blooming of a century plant flower was intense, and she hardly left the room all day as it unfolded. Later, when she had a garden at the Abiquiu house, O'Keeffe grew hollyhocks, red and yellow rose bushes, lavender iris, thistle, poppies, and white chrysanthemums.

In 1946 the Museum of Modern Art presented their first one-woman show, a retrospective culmination of thirty years of O'Keefe's work, including enlargements of flowers, leaves, and shells; landscapes of Lake George and New Mexico; and New York skyscrapers. The most recent theme of southwestern crosses and bones also figured prominently in the show. It was the first time in twenty-two years of annual exhibits that O'Keeffe's paintings had not been shown under Stieglitz's direction. According to Anita Pollitzer, who had accompanied Stieglitz to the opening at the Modern, ". . . There was something about success and acclaim that always depressed him."

This occasion was one of the few times O'Keeffe attended her own opening. After dining with the trustees, O'Keeffe joined museum officials in the large second-floor gallery and greeted the numerous critics, art patrons, and socially prominent New Yorkers who had flocked to the show.

The retrospective at the Modern was scheduled to last until August. Stieglitz and O'Keeffe stayed in New York later than usual that summer, and on June 3 Stieglitz wrote his first letter to O'Keeffe, mailing it in order that it would arrive along with her in New Mexico in the next few days. "And this to be mailed to Abiquiu!! Number 1 of 1946," he wrote, "I greet you on your coming once more to your own country." He added that he is ". . . with you wherever you are. And you ever with me I know." His next few letters exalt in the glory of her exhibit at the Museum of Modern Art, and his pride in her body of work. He wrote of his feelings as the moment of her actual departure neared, hating to see her go but knowing that she needed to be in the desert.

On July 13th, 1946, Alfred Stieglitz died. Earlier that fateful day he had written to O'Keeffe, ". . . I always read your letters first. Kiss—another kiss. Tomorrow I'll go to the [American] Place for a while."

O'Keeffe had been married to Stieglitz for twenty-one years, and she was named executor of his estate (including a large art collection and his own photographs). O'Keeffe spent almost three years organizing and distributing the works to the appropriate institutions and artists. Yale University received the Stieglitz Archives, including letters, catalogs, and other material relating to his involvement during this seminal period of American art.

In an article in *The New York Times* of December 11, 1949, O'Keeffe wrote: "He didn't know what to do with the Collection. Wouldn't do what he could with it . . . He would not mind my doing what it was impossible for him to do."

Black Cross, New Mexico

1929, oil on canvas; 39 x 30 in. (99 x 76 cm). Art Institute Purchase Fund, 1943.95, The Art Institute of Chicago, Chicago, Illinois.
Here, the central portion of the cross hovers over O'Keeffe's beloved desert. The middle ground is dropped out of existence, while the intense foreground detail contrasts with the undulating hills at the horizon.

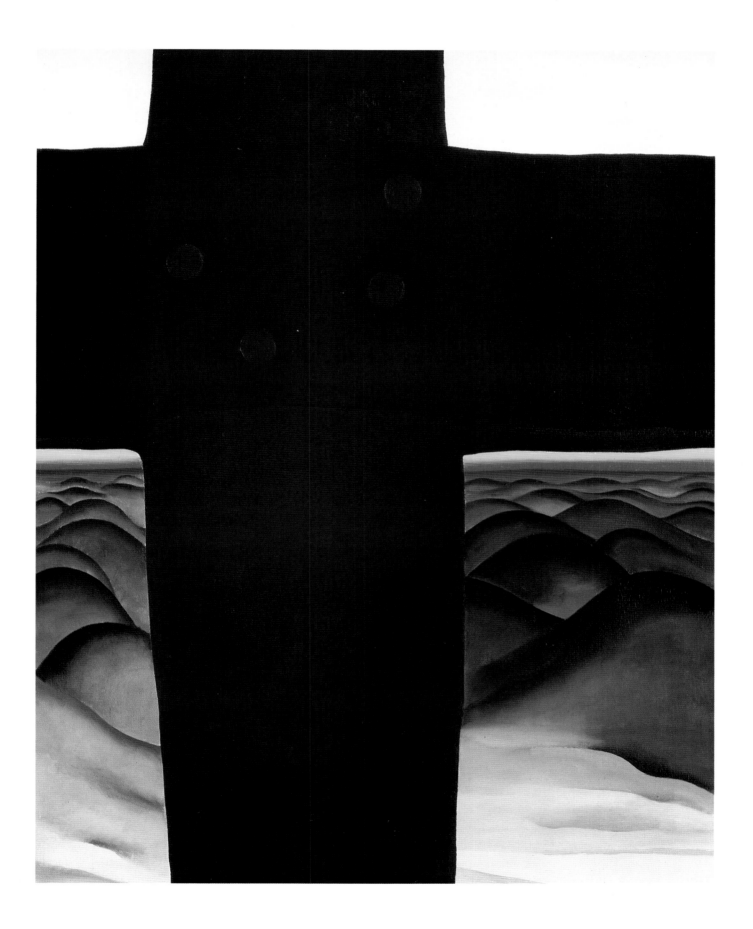

North Courtyard

MYRON WOOD, 1979–1981; photograph. Myron Wood Photographic Collection, The Pikes Peak Library District, Colorado Springs.

Here, O'Keeffe has been photographed walking in the sunlight at her Abiquiu house. She always said that she was afraid the bones over the doorway would fall on her head one day.

ARCHITECTURE

After years of negotiating (first with the owner, then the Catholic Church), O'Keeffe finally succeeded in purchasing a large and dilapidated adobe house in Abiquiu. It had lately been used to house pigs, but Georgia returned it to its former glory as the great house in the region.

From the terrace of the Abiquiu house, she could look down on the valley stretching to the mountains at the horizon. O'Keeffe's love for simplicity showed clearly in her home—there were no paintings hung on the light adobe walls; stones, leaves, bones, and bits of nature were lined up on the wide window ledge of her studio, which was sixty feet long (18.3 meters), with a gorgeous view of the valley below. The plate-glass windows in the living room looked onto a cool, dark walled-in garden, in which O'Keeffe grew vegetables, fruit trees, and flowers. She had missed having a garden at Ghost Ranch as the lack of water there had made it impossible. But at Abiquiu, the shady garden was an oasis, with the acequia (irrigation ditch) flooded with water every Sunday afternoon.

After Stieglitz's estate was settled, O'Keeffe moved permanently to New Mexico. During the winter she lived in the large house in Abiquiu, while her summers were spent in the higher altitude of Ghost Ranch, in the Sangre de Cristo Mountains. Freed from the ties of New York, O'Keeffe also began an extensive series of travels around the world.

Perhaps part of her new adventuresome attitude was due to the way she lived her life in New Mexico. While Stieglitz had always protested about the danger of "such a frail person" living in the wilds of the desert, the Abiquiu community respected the hard-working artist. Though she was only one of two anglos who lived in the town, her love for the place made her belong.

The people in Abiquiu gathered regularly at the church and the cantina, two landmarks on the desert vista. The low church had pink walls, and was hung with huge crosses. The cantina was the center of the Saints' day celebrations, and the place to congregate on Saturday nights. Pollitzer recalled a time when she and O'Keeffe saw six little girls dancing Indian dances

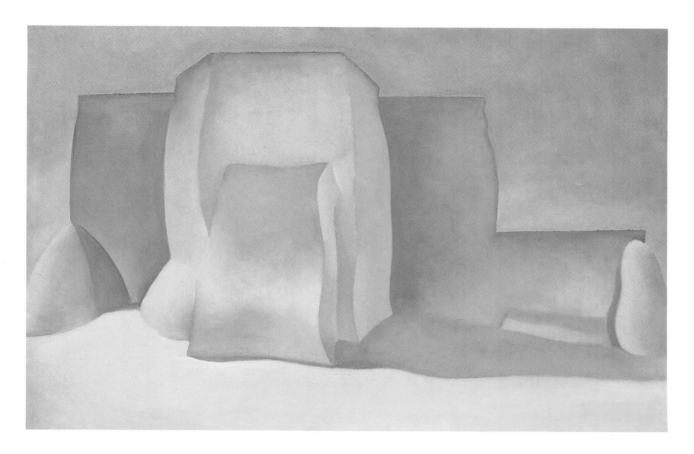

while an old Abiquiu woman clapped her hands. O'Keeffe insisted that a drum should be used, and sent a child to fetch one. The dancing resumed with new vigor, and the old woman gave her an appreciative nod of thanks.

As early as O'Keeffe's first trip to New Mexico in 1929, she had painted some of the churches of the region, particularly the Church of Saint Francis at Ranchos de Taos. The series of black crosses can be seen as compositional reverses of the New York skyscrapers, only now the black man-made form is framed by the all-pervasive sky.

O'Keeffe believed that the architecture in the area was transformed by the dramatic perspectives, particularly at sunrise and sunset, when "the ugly little buildings and windmills looked great against the sky." The artist had focused on architecture in the early watercolors from Texas, isolating a fragment of a

Ranchos Church

1930, oil on canvas; 24 x 36 in. (61 x 91 cm).
The Phillips Collection, Washington, D.C.
Many artists have done studies of the Ranchos Church in Taos. The buttressing of the apse is engineering at a simple geometric level, and the smooth, rounded walls give the blocky planes a vaguely organic appearance.

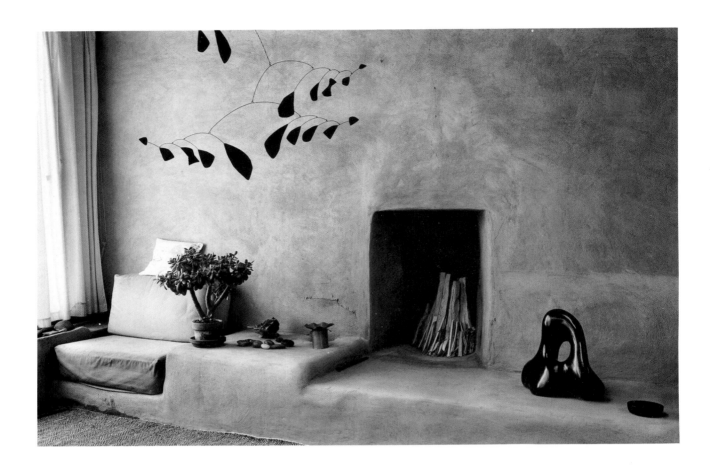

Living Room—Calder Mobile

MYRON WOOD, 1979–1981; photograph. Myron Wood Photographic
Collection, The Pikes Peak Library District, Colorado Springs.

The fireplace in the Abiquiu house is laid with wood for an evening fire. O'Keeffe decorated her homes sparsely; here, the mobile by Alexander Calder and bits of rock and bones are the only ornaments.

building—the gable or a window—but in 1946 she began the unique Patio Door series. Like her studies of barns at Lake George, the patio door represented a place that embodied all the emotional attachments and safety of home.

In the late fifties, O'Keeffe even painted the ladder she used to reach the roof of her house, isolating it over the Pedernal with the quarter moon above. This degree of abstraction captured O'Keeffe's experience of using the ladder to reach the elusive sky, pairing disparate moments of looking up as she climbed with the line of the hills at the horizon.

SKY

O'Keeffe began to travel extensively after World War II, and during one trip to Mexico, in 1951, she drove over 5,000 miles (8,000 kilometers). She was instantly drawn to the art of the Mayan Indians in the ruins of the Yucatán peninsula, and told Anita Pollitzer they were the best things she had seen on her travels.

She took her first trip to Europe in 1953, and toured through France and Spain with Mary Gallery, a sculptor. She called Chartes Cathedral ". . . about as beautiful as anything made by the hand of man could be." She kept returning to see it at different hours of the day, watching the effects of light, particularly through the colored windows.

O'Keeffe also visited the prehistoric caves in Lascaux, location of the famous wall paintings, some of the earliest known examples of art, which date back to 30,000 B.C. As for museums, she could not get enough of the Prado, with its Goyas, Grecos, and Velázquezes.

In the spring of 1956 she went to Peru along with a young, Spanish-speaking woman from New Mexico named Betty Pilkington. O'Keeffe loved the desert of the coast as they drove from Lima into the Andes to see the intricately organic Incan cities, meticulously engineered down to every joint in the stone work.

O'Keeffe went for long visits to Japan and India in 1959, spending a week on a houseboat with a view of the high Himalayas, "one of the most beautiful places in the world." Later she traveled to Hong Kong, the Philippines, Cambodia, and the Pacific Islands. She also visited the Middle East—Baghdad, Beirut, Jerusalem—and went on to Egypt, Greece, and, finally, Italy. An active, adventurous traveler, she even went rafting down the Colorado River through the Grand Canyon several times, and reveled in ruins and art treasures. Her last trip, taken when she was ninety-six, was a return visit to the Pacific coast of Costa Rica.

The paintings she created of these "exotic" locales

Wall with Green Door

1952, oil on canvas; 30 x 47 7/8 in. (76.2 x 121.6 cm). Gift of the
Woodward Foundation, The Corcoran Gallery of Art, Washington, D.C.
From the flat, intersecting plains of the Lake George barns to the stark adobe walls of New Mexico, surfaces and windows—to other places and worlds—appear in O'Keeffe's work throughout her life.

are semi-abstract, postcard views, capturing the rhythm of the setting rather than focusing on the details of architecture and nature. As always, O'Keeffe worked inward on her studies, and usually began by evoking the overall patterns of her subjects.

At this time the artist encountered and enjoyed the aerial view from a plane. The patterns of water runoff served as outlines to the desert swells in the Middle East, and the winding curve of a large river reduced the complexities of land gradations to their most fundamental patterns. O'Keeffe first tried to capture aerial views in her charcoal drawings, evoking the sinuous

Sky Above White Clouds I

1962, oil on canvas; 60 x 80 in. (152 x 203 cm). Bequest of
Georgia O'Keeffe, The National Gallery of Art, Washington, D.C.
This composition illustrates O'Keeffe's inherent affinity
with the minimalist artists—though through decades
of painting she never claimed allegiance to any theory
of art. It can be seen simply as a further step in the reduc-
tionist techniques that persisted until the end of her career.

flow of the terrain below. Then she turned to oils, iso-
lating a fragment of the earth to represent the whole.

She also resumed her cloud studies, focusing on the
universals of the view of the sky from the ground. *Sky
above White Clouds I* (1962) can be considered the cul-
mination of O'Keeffe's quest for an underlying
design within nature. With only the ephemeral
images of clouds—their rich outlines and fine grada-
tions—she had found the perfect subject for the
abstraction of nature.

With the vast sky of the southwest ever changing
overhead, O'Keeffe created what were essentially
minimalist compositions. Yet while other modern
artists reduced their paintings to the most minimal
elements simply as a means to an end, O'Keeffe was
searching nature for its absolutes. As she said,
"There's nothing abstract about those pictures; they
are what I saw—very realistic to me." She admitted to
changing the color, adding that, after all, "you can see
any color you want" when you look from the window
of an airplane.

Her reductionist view was basically a way to find and observe the solid tangibles in life—those things that endure despite changes and monumental events. In doing so, O'Keeffe captured infinite complexity in forms of infinite emptiness. Using only two planes of color, she stepped squarely up to that edge of what, years earlier, her fellow modernist Marsden Hartley had called "the borderline between finity and infinity," where the viewer is projected into space, floating along with the elements in the void.

In an era when science began developing a reductive analytical sense, using the new technologies of the microscope to enlarge images and the camera to slow down motion, O'Keeffe was determined to pursue her reductive campaign. She continued to paint late into her life, and a documentary film celebrating her ninetieth birthday shows her climbing briskly through the New Mexico desert, firmly attesting to her remarkable energy and longevity. Despite the fact that she lost her central vision in the early 1970s, O'Keeffe continued to work, turning her active focus to sculpture.

Her young assistant, artist Juan Hamilton, began to help O'Keeffe with her exhibits and publications as well as with her creative work. Using her peripheral vision and innate memory of the patterns of life, O'Keeffe worked until the year she died—some of her last works include drawings of the California redwoods she saw while visiting photographer Ansel Adams.

Georgia O'Keeffe died leaving behind a vast, nearly century-long body of work uniquely expressive of her singular vision of life. Her compositions were dependent on the details of her subjects, and their monumental quality lay in their transcendence from the particulars to the essence of the object. She remained faithful to this vision throughout her career. Her constant exploration, which plumbed the depths of a variety of subjects, may be the reason that she was able to endure the rapid transitions of art movements during this century.

O'Keeffe never quite fit into the mainstream of the art world, but her works always seemed to express the same ideals that the popular theories were exploring. Her genius is that while she can be considered a "modern" artist, she showed her powerful vision through the subjects she painted—a truly traditional and durable means of expression.

Georgia O'Keeffe

Unknown Photographer, 1970. UPI/Bettmann, New York.
O'Keeffe, photographed on October 21, 1970, less than a month before her eighty-third birthday, and the year of her second major retrospective at the Whitney Museum of American Art in New York.

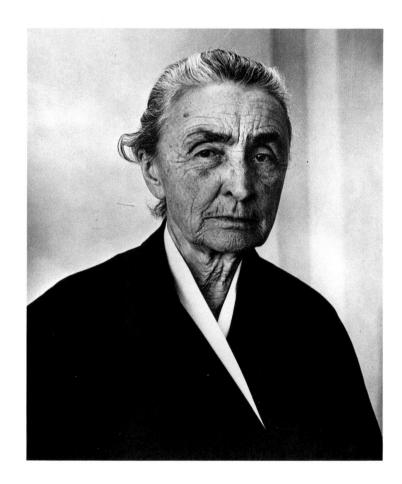

Horse's Skull on Blue

1930, oil on canvas; 30 x 16 in. (76 x 41 cm).

Arizona State University, Art Museum, Tempe, Arizona.

O'Keeffe said of her series of bone paintings
that ". . . bones are as beautiful as anything I
know. To me they are strangely more living than
the animals walking around—hair, eyes and all . . . "

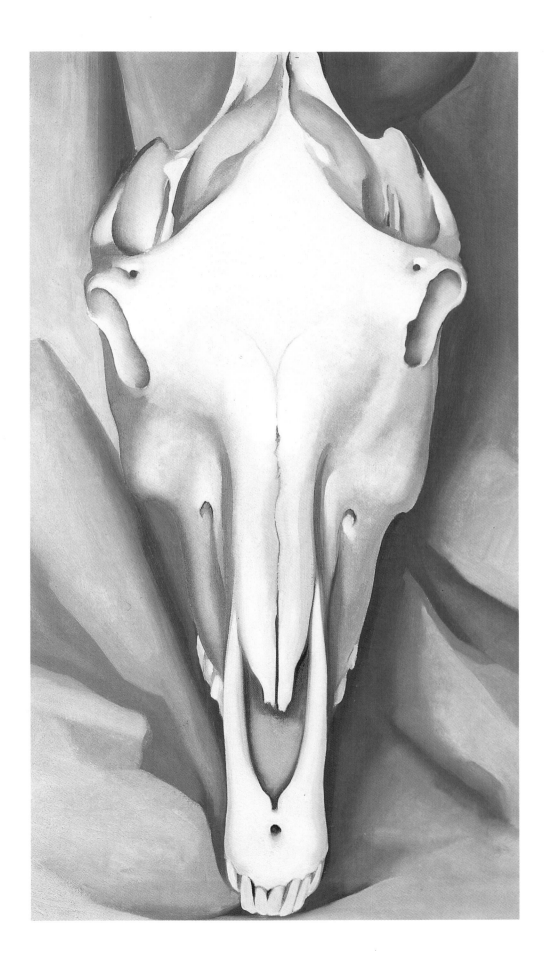

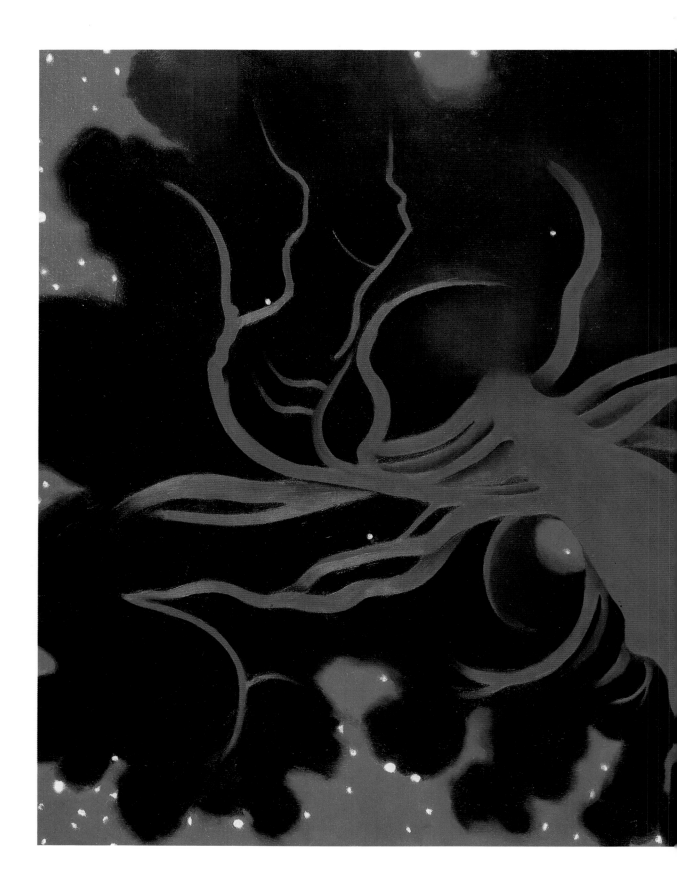

The Lawrence Tree

1929, oil on canvas; 31 x 39 in. (79 x 99 cm).
The Ella Gallup Sumner and Mary Catlin
Sumner Collection Fund, Wadsworth
Atheneum, Hartford, Connecticut.
The unusual perspective of this
painting instantly orients the viewer
so that one is standing beneath the
tree. In this way, O'Keeffe creates
an "equivalent" to her experience
of the grandeur of the desert night.

The Old Cemetery

MYRON WOOD, 1979–1981; photograph.
Myron Wood Photographic Collection, The
Pikes Peak Library District, Colorado Springs.
A weathered wooden cross is silhouetted
against the sky. The plastic flowers at the
base and transept are typical of the area.

Gray Cross with Blue

1929, oil on canvas; 36 x 24 in. (91 x 61 cm). Purchase, 1883/1985
G. O. Bonds; Albuquerque Museum Foundation; Ovenwest Corporation; Frederick
R. Weisman Foundation, Collection of the Albuquerque Museum, New Mexico.
Despite her Catholic background, O'Keeffe did not paint crosses as
religious symbols but simply as an image that pervaded the attitudes of
the people in the southwest. She once told critic Henry McBride that
"anyone who doesn't feel the crosses simply doesn't get that country."

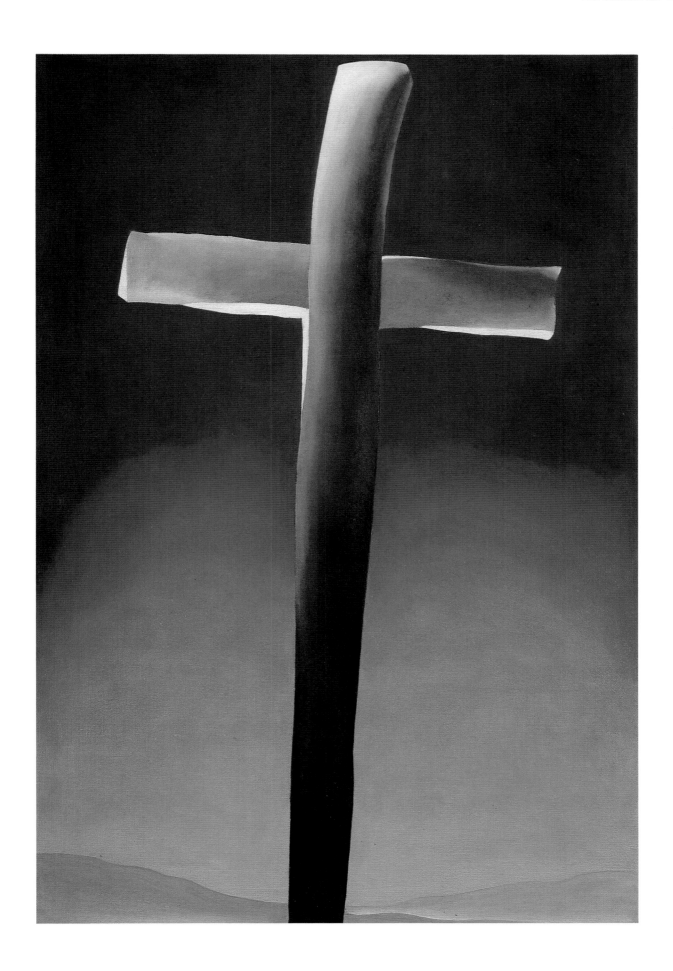

Red Hills and Bones

1941, oil on canvas; 30 x 40 in. (76 x 102 cm). The Alfred Stieglitz
Collection, The Philadelphia Museum of Art, Philadelphia, Pennsylvania.
From her house in Abiquiu, New Mexico, O'Keeffe wrote
to Maude and Frederick Mortimer, ". . . I drove up the canyon
four or five miles when the sun was low and I wish I could
send you a mariposa lily—and the smell of the damp sage . . ."

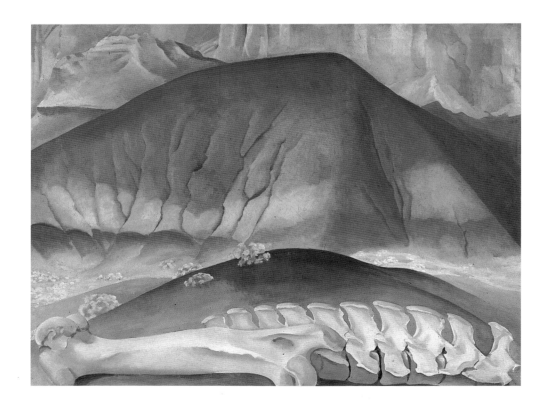

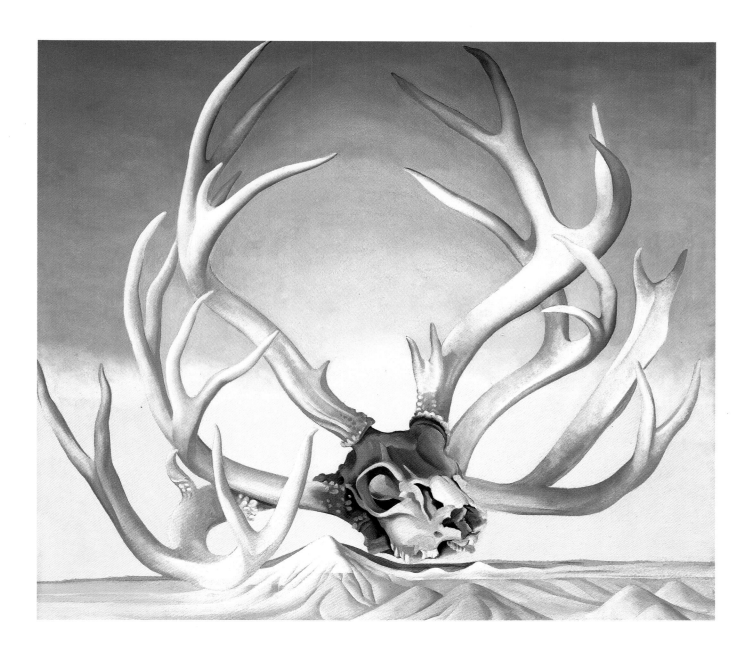

From the Faraway Nearby

1937, oil on canvas; 36 x 40 1/2 in. (91 x 103 cm). The Alfred Stieglitz
Collection, 1959, The Metropolitan Museum of Art, New York.
O'Keeffe exhibited this painting under the title *Dear's Horns Near Cameron* in her
retrospective exhibition at the Art Institute of Chicago in 1943. She visited Cameron,
Arizona, with photographer Ansel Adams in 1937, but thought this painting to be
representative of the entire southwest—what she referred to as "the faraway."

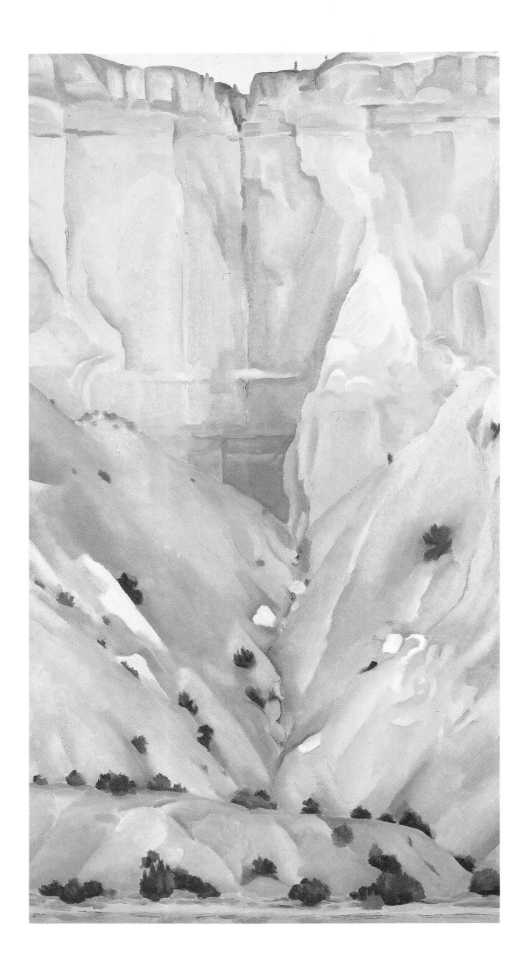

Cliffs beyond Abiquiu, Dry Waterfall

1943, oil on canvas; 30 x 16 in. (76 x 41 cm). Bequest of
George O'Keeffe, 1987.141, The Cleveland Museum of Art, Cleveland, Ohio.
When photographer Ansel Adams visited O'Keeffe in New Mexico in 1937,
he wrote to Stieglitz of "the detail so precise and exquisite that wherever you
are, you are isolated in a glowing world between the macro and the micro . . ."

Pelvis with Blue (Pelvis I)

1944, oil on canvas; 36 x 30 in. (91.4 x 76.2 cm). Gift of Mrs. Harry Lynde Bradley, Milwaukee Art Museum, Milwaukee, Wisconsin. In the 1940s, when O'Keeffe saw what the young minimalist painters were doing with patterns of pure color, she realized that she had been working toward this ultimate simplification throughout her career— seeking that point where nothing turned into something.

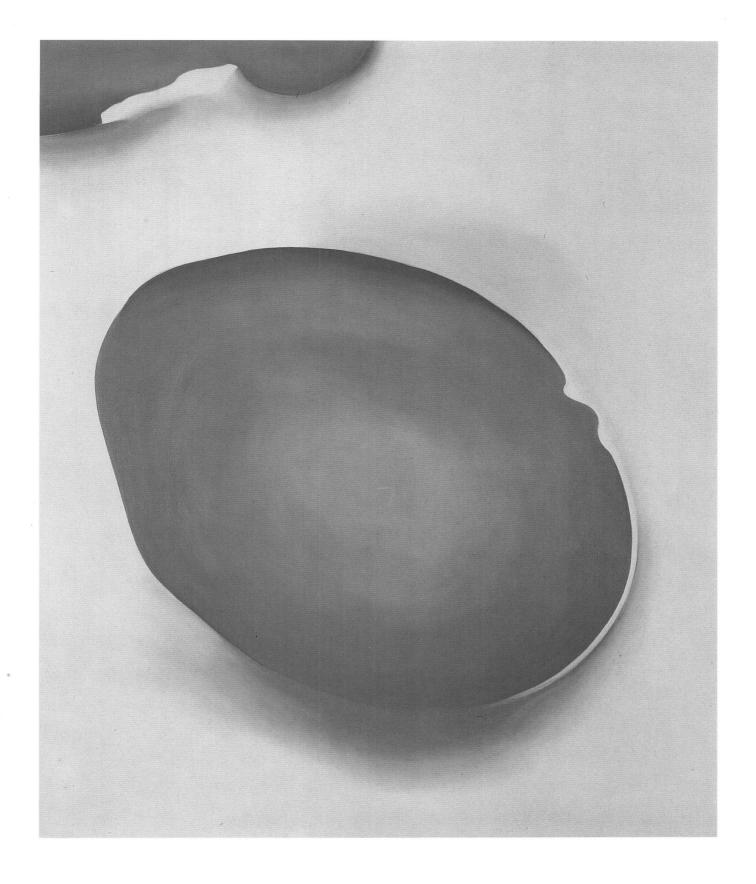

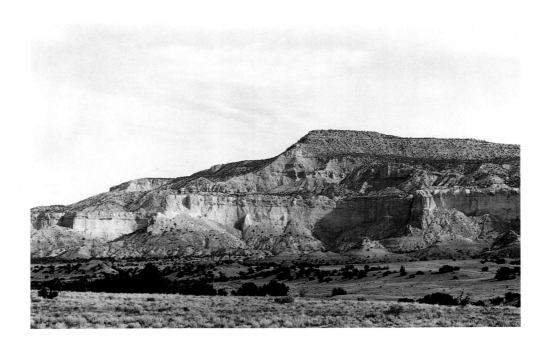

New Mexico

MYRON WOOD, 1979–1981; photograph.
Myron Wood Photographic Collection, The
Pikes Peak Library District, Colorado Springs.
These are the sand hills that O'Keeffe
painted—south of the town of Abiquiu.

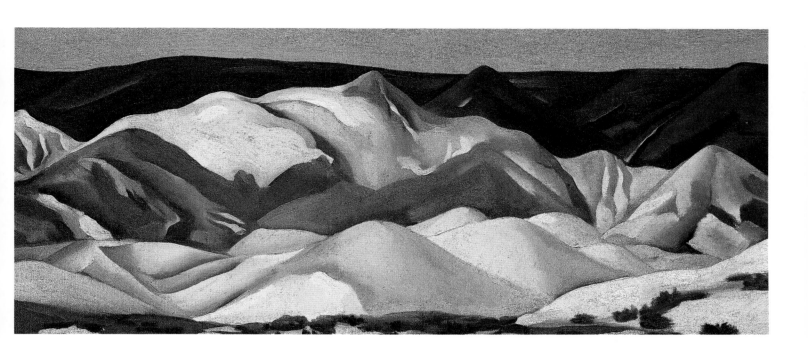

Near Abiquiu New Mexico

1930, oil on canvas; 10 x 24 1/8 in. (25.4 x 61.3 cm). The Alfred
Stieglitz Collection, 1963, The Metropolitan Museum of Art, New York.
The soft, organic forms of the hills near Abiquiu swell from the
barren landscape into the limitless sky above. These hills are almost
alive, and they breath and move with the incredible landscape.

Winter Garden

*MYRON WOOD, 1979–1981; photograph. Myron Wood Photographic
Collection, The Pikes Peak Library District, Colorado Springs.*
The garden of the Abiquiu house takes on a
very different aspect under a blanket of snow—
becoming almost northeastern in character.

**Formal Entrance
(The Garden at Abiquiu)**

MYRON WOOD, 1979–1981; photograph. Myron Wood Photographic

Collection, The Pikes Peak Library District, Colorado Springs.

The broad adobe walls of the Abiquiu house

were handmade by women in the village.

Wagon Mound, New Mexico

MYRON WOOD, 1979–1981; photograph.
Myron Wood Photographic Collection,
The Pikes Peak Library District, Colorado Springs.
The trees of the Southwest have a distinctive
shape and presence that is perhaps even more
powerful than the birches and oaks O'Keeffe
painted during her time in Lake George.

Black Hills with Cedar, New Mexico

1941, oil on canvas; 16 x 30 in. (41 x 76 cm). The Joseph H. Hirshhorn Bequest, 1981,
Hirshhorn Museum and Sculpture Garden, Smithsonian Institution, Washington, D.C.
Here, O'Keeffe emphasizes the shadowy hollows of the hills,
unlike paintings that focus on the softly rounded swells, such as
the earlier *Grey Hill Forms*. Eventually, as she grew more
familiar with the site, the painter began to invent new hues to
describe the patterns she was teasing out of the landscape.

Blue B

1959, oil on canvas; 30 x 36 in. (76 x 91 cm).
The Milwaukee Art Museum, Milwaukee, Wisconsin.
While traveling by airplane during extensive
worldwide trips, O'Keeffe enjoyed her
bird's-eye view of the land. Her 1959 abstract
studies—first in charcoal, then in oils—
helped to formalize her distinctive sense
of color into the patterns of landscapes.

Sky Above Clouds IV

1965, oil on canvas; 8 x 24 ft. (2.4 x 7.3 m). Restricted Gft of the Paul and Gabriella Rosenbaum
Foundation, Gift of Georgia O'Keeffe, 1983.821, The Art Institute of Chicago, Chicago, Illinois.
This work, the largest canvas O'Keeffe ever painted, was inspired by a 1962 series
of "cloudscapes." She completed the canvas when she was in her late seventies,
yet it was not the crowning glory that she had been hoping for. Although the
painting was the cornerstone of her 1970 Whitney exhibition, it is generally
viewed by critics as a curiosity rather than a seminal work in the artist's oeuvre.

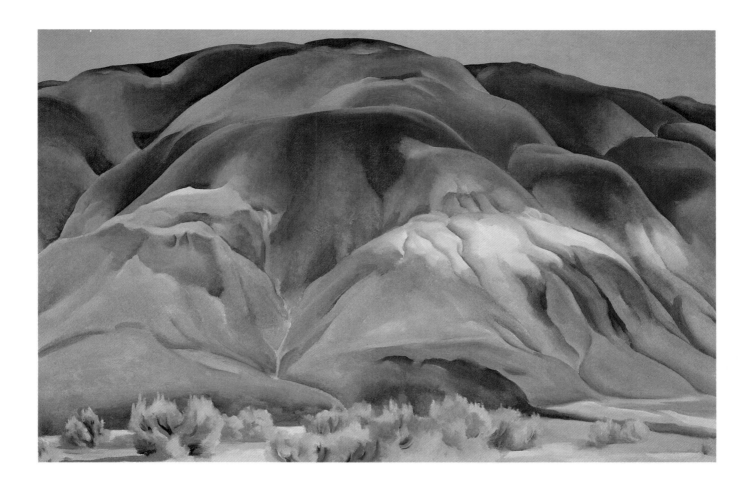

Grey Hill Forms

1936, oil on canvas; 20 x 30 in. (51 x 76 cm). Gift of the Estate of Georgia O'Keeffe,
The University of New Mexico Art Museum, Albuquerque, New Mexico.

These are the low sand hills near Alcalde that many painters of the day
tried to tackle as a subject. The subtle shifts in dramatic colors as well
as its monumental scale at first proved to be a challenge to O'Keeffe.
It was one of the reasons she persisted in returning to the site, trying
to capture a fragment that reduced the hills to their essential form.

Bones, Ghost Ranch

MYRON WOOD, 1981; photograph.
Myron Wood Photographic Collection, The
Pikes Peak Library District, Colorado Springs.
Skulls and horns that O'Keeffe
collected at Ghost Ranch are
reflected along with the desert
in the window of her house.

Rib and Jawbone

1935, oil on wood, 9 x 24 in. (22.9 x 61 cm). Bequest of Georgia O'Keeffe, The Brooklyn Museum, New York.
Here, in a simple and representational rendering, are some of the bones that O'Keeffe found so inspiring as subjects for her work.

New Mexico

*MYRON WOOD, 1979–1981; photograph. Myron Wood Photographic
Collection, The Pikes Peak Library District, Colorado Springs.*
Reminiscent of the dramatic sweeps and chasms depicted
in *It Was Blue and Green*, the New Mexico landscape
offers an infinity of spatial possibilities to the inquiring eye.

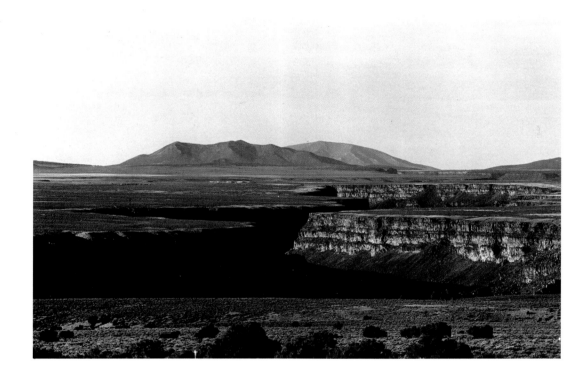

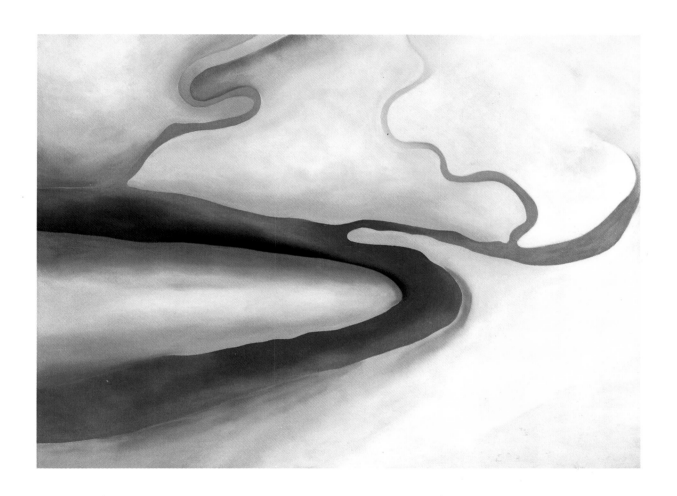

It Was Blue and Green

1960, oil on canvas; 30 x 40 in. (76.2 x 101.6 cm). Bequest of Lawrence H. Bloedel,

The Whitney Museum of American Art, New York.

By 1960, O'Keeffe had reduced the curves and sweeps of the

New Mexico landscape to an abstract, almost minimal interpretation.

Yet her work is still lush and organic, filled with the pulse of the living earth.

INDEX